BEAUX ARTS
TO BAUHAUS
AND BEYOND

BEAUX ARTS
TO BAUHAUS
AND BEYOND
AN ARCHITECT'S PERSPECTIVE

By Harold Bush-Brown, FAIA

WHITNEY LIBRARY OF DESIGN
an imprint of
Watson-Guptill Publications/New York

To my wife, Marjorie,
whose unceasing help and
encouragement stimulated me
to carry on in spite of
delays and uncertainties.

Copyright © 1976 by Whitney Library of Design
First published 1976 in New York by Whitney Library of Design,
an imprint of Watson-Guptill Publications,
a division of Billboard Publications, Inc.,
1515 Broadway, New York, N.Y. 10036

Manufactured in U.S.A.

Library of Congress Cataloging in Publication Data
Bush-Brown, Harold.
 Beaux arts to Bauhaus and beyond.
 Includes index.
 1. Bush-Brown, Harold. 2. Architects—United
States—Correspondence, reminiscences, etc.
3. Architecture, Modern—20th century. I. Title.
NA737.B87A22 720'.92'4 [B] 76–17005
ISBN 0–8230–7067–0

First Printing, 1976

Edited by Susan Braybrooke and Susan Davis
Designed by Jim Craig
Set in 11 point Palatino by Gerard Associates/Graphic Arts, Inc.

Contents

Foreword

When Harold Bush-Brown asked me what I thought of the title of his book, I told him it could hardly be bettered, since his perspective on the profession is unique.

His perspective begins from the vantage point of a young man educated in the Beaux Arts tradition who in 1911 served his apprenticeship with McKim, Mead, & White in New York and in 1915 joined the firm of Cram & Ferguson in Boston. He went on to be head of the Department of Architecture at Georgia Tech at the time when the modern movement was usurping Beaux Arts principles as the guiding philosophy for architectural education. In the late fifties he played a leading role in shaping national policy on architectural education as chairman of the Joint Association of the Collegiate Schools of Architecture and American Institute of Architects Committee on the Teaching of Architecture. He later had first-hand experience with the client's point of view when he headed a local building committee in his home town of Duxbury, Massachusetts, and supervised the addition of a modern wing to a classical library building.

With these as his progressive viewpoints, Harold Bush-Brown unrolls the years with the wisdom and detachment of someone who has lived through many changes, but has achieved the inner serenity that allows him to contemplate without dismay the possibility of many more.

My first recollection of Harold Bush-Brown, when he addressed my entering class at Georgia Tech and welcomed us to the pursuit of architecture, is of a personality who — even in appearance — fulfilled my rather idealized picture of the architect. As a lecturer on architectural history, he made it one of his requirements that his students draw the plans, elevations, and sections of historic buildings that were being studied in the course. This was a master stroke, as it not only imprinted on our minds the details and essence of these great buildings, but it trained the hand in draftsmanship at the same time.

Harold Bush-Brown had the gift of nurturing the talents and ambitions of the young without imposing his own views upon them. He was able to accept and promote drastic changes heralded by the Bauhaus without losing his perspective or his respect for the past. He was always able to recognize that new forms emerge from their antecedents, even if in violent reaction to them. Unlike Gropius, he never abandoned the history of architecture as a necessary requisite in the education of an architect. It is perhaps significant that Gropius in the end changed his mind, and reinstated history as part of the architectural curriculum at Harvard.

Beaux Arts to Bauhaus and Beyond is inevitably autobiographical, but since the autobiography unfolds in close interaction with one of the most dramatic

periods in the history of architecture, Harold Bush-Brown's personal perceptions of events and personalities as well as his picture of the evolving professional role and image of the architect are of abiding interest to us all. Moreover, he recounts the tale with love and understanding — and always a touch of perceptive humor — qualities all too rare in architectural commentary these days.

At 88 years young, Harold Bush-Brown has retained the vitality, vivid memory, and the extraordinary good sense that characterized him as a teacher and educator. His book has as much to offer the concerned layman as it has the professional. And he has done that difficult thing . . . made it interesting and intelligible to both.

Hugh Stubbins, FAIA
Cambridge, Massachusetts

Preface

Retirement from directorship of the School of Architecture at the Georgia Institute of Technology in Atlanta led to a return to New England in 1957 to an inherited house in Duxbury, Massachusetts, which, with some alterations, became a residence for Mrs. Bush-Brown and me. Several years later I was called upon to serve on committees charged with recommending, and eventually with the responsibility for building, a new library.

After becoming increasingly involved, it suddenly occurred to me that there was a story to be told that might be of interest to residents of this and similar neighboring communities. This narrative would show how members of the committee and the architects whom they appointed handled the many problems that they encountered in their search for a satisfactory solution. The book, if one should result from the record I was about to write, was to be entitled, *The Biography of a Building*.

The original library of 1907–1909 was of classical design by a Boston architect who was an authority on what he called "colonial": the American tradition derived from the period before and just after the founding of the nation as a republic. There was never any question that, in contrast to the former building, the addition would be contemporary, that is, "modern."

It seemed to me that there was a need for an explanation that included an account of the origin and nature of the drastic, fundamental, revolutionary change that had taken place between the time of the original library of 1908 and the year 1968, when the addition was being constructed. To understand how and why the addition differed from the earlier building seemed to call for a recital of many incidents in my personal experience as a student, practitioner, and teacher, which, I hoped, would reveal what is meant by modern design as it appears in the addition and how it differs from the original traditional building.

Broadening the base of this narrative to include names and happenings from my earlier life in New York, Boston, and Atlanta meant that the story was about to become less parochial and more descriptive of an era. Thus it seemed appropriate to adopt a new title, which appears on the first typed, revised manuscript, *Architecture in a Changing World*, with *The Biography of a Building* retained as a subtitle.

As I continued to write and enlarge upon the last few chapters, the subject unconsciously and perhaps inevitably seemed to expand, encompassing a more extended view beyond my own experiences to include references to the contributions of some of the pioneers of the new movement throughout the Western world. This constituted a further departure from the initial intent.

Guided by what seemed to be an impelling impulse, I found that the

coverage was becoming more and more extended, focusing less and less on the Duxbury Library. I began feeling that *The Biography of a Building* was not sufficiently related to the text and was too limiting to be used any longer as a title. After reading the manuscript, my friend, Gerald Howes, who is an architect, teacher, and writer, suggested that it might be better to present the subject as a memoir.

Eliminating *The Biography of a Building* did not signify that the Duxbury Library was being abandoned. In spite of its modest dimensions, it should be considered an especially relevant example of architecture in a changing world, and for me it continues to be an anchorage in a home port to which, no matter how often the departure or how long the voyage, I always return.

When the Whitney Library of Design became interested in publishing the book, a final version of the title was arrived at that identified the major conflict and sources of change: *Beaux Arts to Bauhaus and Beyond: An Architect's Perspective.*

The recollection of the events of my professional life begins with student days at Harvard when I decided upon architecture as a career. As I look back, I realize that what followed graduation was a period of unprecedented crises and uncertainty: two world wars and the worst depression in the nation's history. Of greater significance in the record about to be recounted were the changes taking place in our society that were reflected in our architecture: changes in form and character brought about by new demands and technological advance. The changes and advance between 1908 and 1968 were nothing short of revolutionary — a bloodless revolution to be sure, but nonetheless devastating.

Although it is not possible to list everyone who helped me in one way or another, I do wish to acknowledge the good advice and encouragement I received from the following people who read through the manuscript: Connie (Mrs. George A. L.) Brown; John O. Chesley of Morehouse & Chesley, architects, Lexington, Massachusetts; Dorothy (Mrs. Boyd C.) Dennison of the Duxbury Library; James Grady, Professor, and Paul M. Heffernan, Director, School of Architecture, Georgia Institute of Technology, Atlanta, Georgia; Gerald Howes, architect; Samuel T. Hurst, Director, University of Southern California, Los Angeles, California; Katherine (Mrs. Francis) Rogers; Priscilla (Mrs. Daniel H.) Sangster of the Duxbury Clipper; Hugh Stubbins of Hugh Stubbins and Associates, architects, Cambridge, Massachusetts; and Gay Youse, supervisor of art exhibits, Duxbury Library. Lastly many thanks go to my editors at the Whitney Library of Design: Susan Braybrooke, Acquisitions Editor, and Susan Davis, Development Editor.

Introduction

My life began when my artist parents were on an extended tour of Europe. I was born in Paris in 1888, one year after the birth of my sister in Florence.

We sailed back to America when I was ten months old. My father liked to tell the story of how I had a crying spell in our stateroom. No matter how hard they tried to quiet me, I kept right on crying. Finally, he picked me up, opened the porthole, and thrust me out into the open. I immediately stopped crying and gave no further trouble. I attribute my fondness for the distant view to this incident.

We settled on the outskirts of Newburgh, New York. My father, who was christened Henry Bush, inherited the place from his uncle, H. K. Brown, a sculptor, who adopted him as his son. Hence the family name Bush-Brown and hence also my father's training and lifework as a sculptor.

My great-uncle, who became prominent as a sculptor of equestrian statues, built several buildings in addition to the house — a carriage house, stables, and a huge studio. A smaller studio for my mother, who was a painter, was constructed later by my parents over a portion of the stables.

When I was 4 and 5 years old, I remember my father working on the Buffalo Group: an Indian on a horse rearing up over a buffalo that was being pierced with arrows from the Indian's bow.[1] What impressed me the most at that age were the models: the real live buffalo in the pen outside the studio and the Indian man who lived in the third story of our house.

My mother's parents, Peter and Susan Lesley of Philadelphia, spent the last years of their lives in Milton, Massachusetts, and Milton Academy is where I attended school for five years. Returning to Newburgh upon the death of my grandparents, I attended public schools for the last three years before entering Harvard in 1907.

It was at Harvard that the story of my professional life as an architect and a teacher of architecture begins.

Photograph on page 12: Elegant eclecticism of turn of the century architecture is typified in the Renaissance revival New York Police Headquarters, 1909. Architects Hoppin & Keon. Photograph by James Brett.

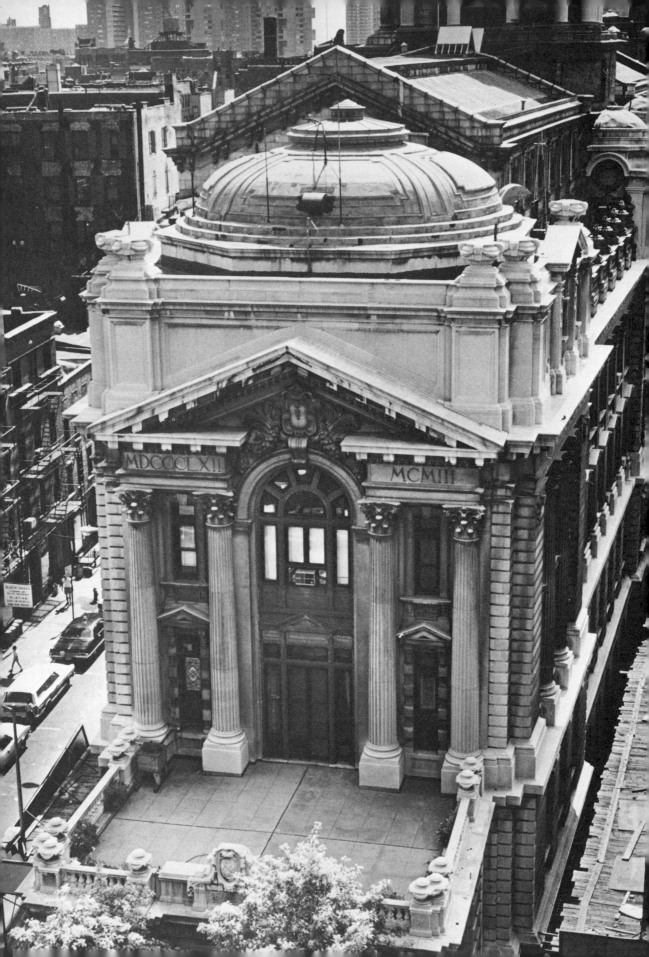

1. Beaux Arts: My Formative Years

If I remember correctly, it was during my sophomore year at Harvard that I decided to become an architect. This was in 1908, the year the original Duxbury Library (discussed in Chapter 4) was under construction.

The decision to be an architect was not a foregone conclusion, as I well remember consulting my advisor on the subject. In those days every student was assigned a professor to advise him on his curriculum and his future. I told him I had been unable to make up my mind among three professions: the law, forestry, and architecture. The extent of his advice consisted of telling me that he could not see any relationship among those three choices. Nor could I, and on that note the interview ended. Considering that both my parents were artists, it is not surprising that architecture was my ultimate choice.

I n 1911 I worked in New York in the office of McKim, Mead, & White. My father, as the sculptor of the Buffalo Group, which was chosen to occupy a central position in the Chicago Columbian Exposition or World's Fair of 1893, had become acquainted with Mr. Mead and through him arranged for my employment. This interrupted my formal education at Harvard, but gave me the opportunity of viewing the workings of the architectural profession from within.

In earlier days, before there were schools of architecture in this country, the apprenticeship system was in vogue. A draftsman learned his trade in the office, with the older men taking responsibility for training the beginners. In some of the larger, long-established firms, the system had not entirely died out, and in a firm like McKim's it was not unusual for a beginner to work for nothing just to obtain a start. Considering that I had barely begun to study architecture in college and totally lacked experience, I was expected to be grateful for making $10 a week. It *was* a privilege to be in the office of the most prestigious firm in the country, but at the time I was there, there was little in the way of real education. The training of architects was shifting to educational programs offered at the Massachusetts Institute of Technology, Cornell, the University of Illinois, Syracuse, Columbia, the University of Pennsylvania, Harvard, and a few others, where full-fledged courses in architecture had been established.

Some of America's leaders had little or no formal education in architecture. This was true of Ralph Adams Cram and Bertram Goodhue, partners in the firm of Cram, Goodhue, & Ferguson before the split, and also of Frank Lloyd

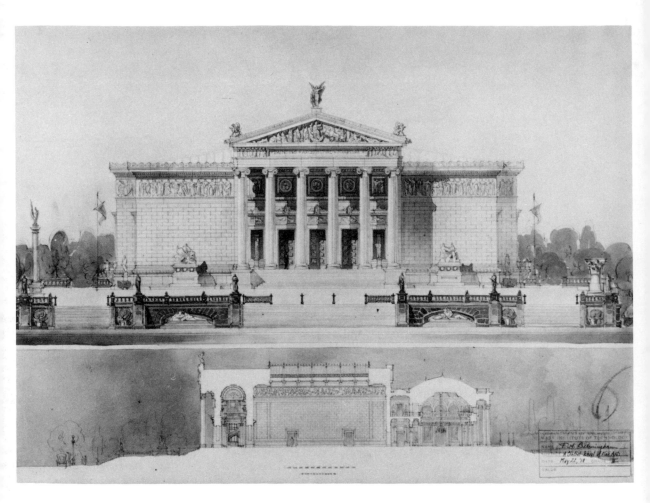

Around the turn of the century, the French L'École des Beaux Arts system was followed in most American university architecture courses. Franklin A. Bermingham's 1918 design for a Central School of Fine Arts demonstrates the Beaux Arts influence in design conception and rendering techniques. Courtesy Massachusetts Institute of Technology Historical Collections.

DEPARTMENT OF AR
MASS. INSTITUTE OF

NAME F. A. Bourne

SUBJECT

DATE May 22, '18

VALUE

Wright. But for the ordinary mortal, a well-prescribed educational program was considered essential if one expected to become an architect.

Around the turn of the century it was fashionable, at least for New Yorkers, to go to Paris for their education, especially to the famous French school, L'École des Beaux Arts. Yet those who entered one of the newly established American schools also came under the influence of the Beaux Arts, as most schools brought in French architects to take charge of the design curriculum. Hence the Beaux Arts system was closely followed in most American universities offering degrees in architecture at that time.

McKim, Mead, & White was the foremost firm dedicated to classicism inspired by the Italian Renaissance. Fifth Avenue was lined with banks, store fronts, clubs, and millionaires' mansions that originated in the drafting rooms of their midtown office. Unfortunately, almost all these buildings have had to give way to bigger, though not necessarily better, examples of the expanding metropolis.

A few years before I began my apprenticeship, the firm had suffered a calamity. McKim had died and Stanford White had been murdered in one of the most sensational scandals in American history. It was these two men—two very different types—who had brought fame and success to the firm. Typical of McKim's best work is the beautiful J. P. Morgan Library on West 36th Street, a perfect example of restrained academic adherence to classical formulation. White, the producer of extravaganzas, made use of a profusion of classical ornament taken from the Italian Renaissance. Two examples of this approach with which I was familiar were the Herald-Tribune Building and the original Madison Square Garden, both supplanted now by very different types of structures. It was while dining in the latter that White met his death at the hands of a man crazed by jealousy.

Mead, the third member of the firm, was once asked, "We have all heard of McKim as the designer of certain buildings and of White as the designer of certain other buildings, but what, Mr. Mead, do you do?" His answer was, "I just keep McKim and White from making fools of themselves."

In my nine months' stay in their office I never once saw Mr. Mead so far as I was aware, and I assume he had ceased to be very active. In place of the three former principals were five or six men, each experienced in handling special types of buildings. And there were younger men, most of them graduates of the University of Pennsylvania, who took an active role in the early creative stage of the design process. (The University of Pennsylvania was looked upon as the outstanding school because of the reputation of Paul Cret, a Frenchman of Beaux Arts background, who brought fame to the school through his students' designs as well as by his own work as an architect.)

In the New York office, which was to continue under the name of McKim, Mead, & White for a generation, I was given a table in a huge room, which was

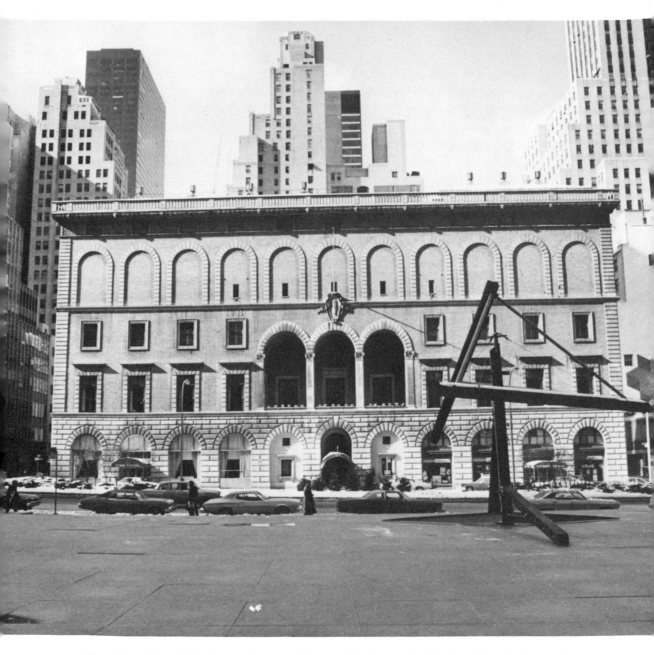

Classical origins of the Beaux Arts period were clearly revealed in the clubs, banks, and mansions designed by McKim, Mead, & White that were once liberally sprinkled through New York and are now fast disappearing. The Racquet and Tennis Club, 1918, at 370 Park Avenue is a gallant and elegant survivor. Photograph by Martin Munter.

fully occupied by draftsmen. My initiation, if that's what it was, consisted of rubbing out what was wrong or being changed in the work of others. That kept me busy for two or three days. I was told of former initiations: one man without any experience was sent to another architect's office to bring back a vanishing point, which, he was told, had been loaned. On announcing what he had come for, he was informed it had been loaned to another firm, and the experience was repeated. After visiting most of the architects' offices nearby, he returned without ever having found what he was seeking. The lesson he learned was that a vanishing point is the point on a drawing on which all parallel lines converge in a perspective. It's not something you can carry around in your pocket!

In the center of the big drafting room I noticed that one man was constantly being approached by men who consulted him about their drawings. It seems he was the structural engineer for the high building being designed for the employees of the city of New York in the downtown City Hall Square. It was an unusual building, with a major cross street running through it under a Roman barrel vault, which appeared to be holding up the many stories directly above it. This building, which I have come to regard as the most nearly successful attempt to dress a skyscraper in classical attire, must have presented many problems of structure to be solved by the man in the middle.

One of the specialists, of whom there were many, was a man with an Italian name who, I was informed, spent all his time designing the handsome Roman lettering that played such an important part on all the major works of this famous firm.

One of the buildings being designed in McKim's office was a 22-story office building in downtown New York. Of course, it was classical, and so the lower three stories were treated as a base, with orders applied; the stories above constituted the shaft; and the top two-and-a-half stories, the entablature, terminated in a magnificent, highly decorated cornice. Projecting at 45 degrees, it blocked off the top story, increased the shadow cast on neighboring buildings and the narrow street below, and served no purpose, as no one could see it without craning his neck—a posture no New Yorker would think of assuming. It was not for a mere neophyte to question why, and I don't recall that I had any thoughts on the subject at the time. But now I know that even then there were those who were questioning the application of traditional styles to types of structures like the skyscraper, now made possible by modern technology, giving them a function and a form unprecedented in history.

New York's Municipal Building, designed by McKim, Mead, & White in 1914, was one of the more successful attempts to dress a skyscraper in classical attire. The Roman barrel vault marking the axis of Chambers Street through the building was an innovative piece of engineering. The vault is now the entry portal to the new Police Headquarters, from which James Brett's photograph was taken.

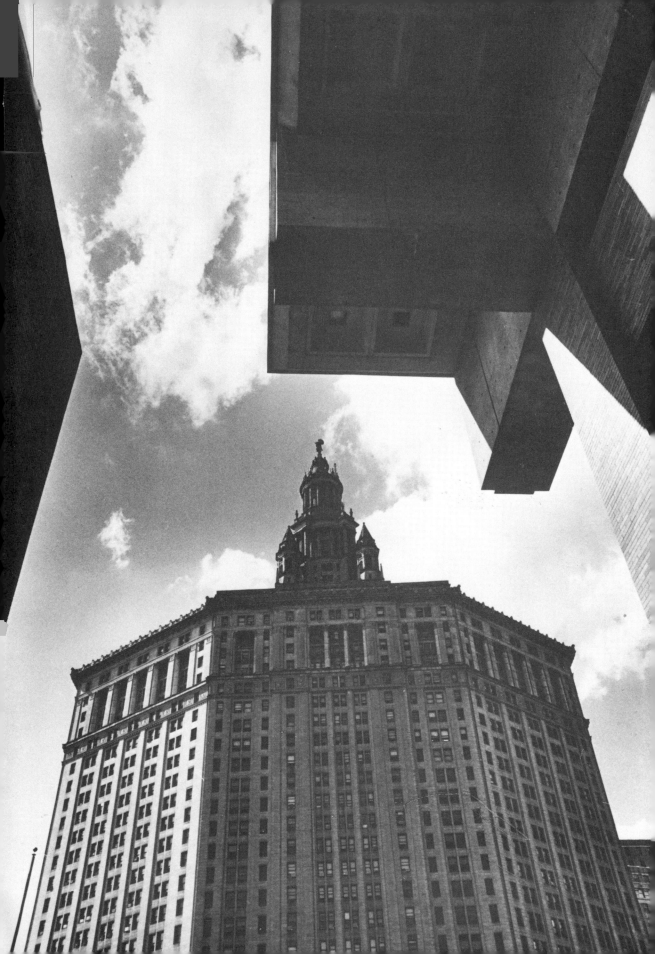

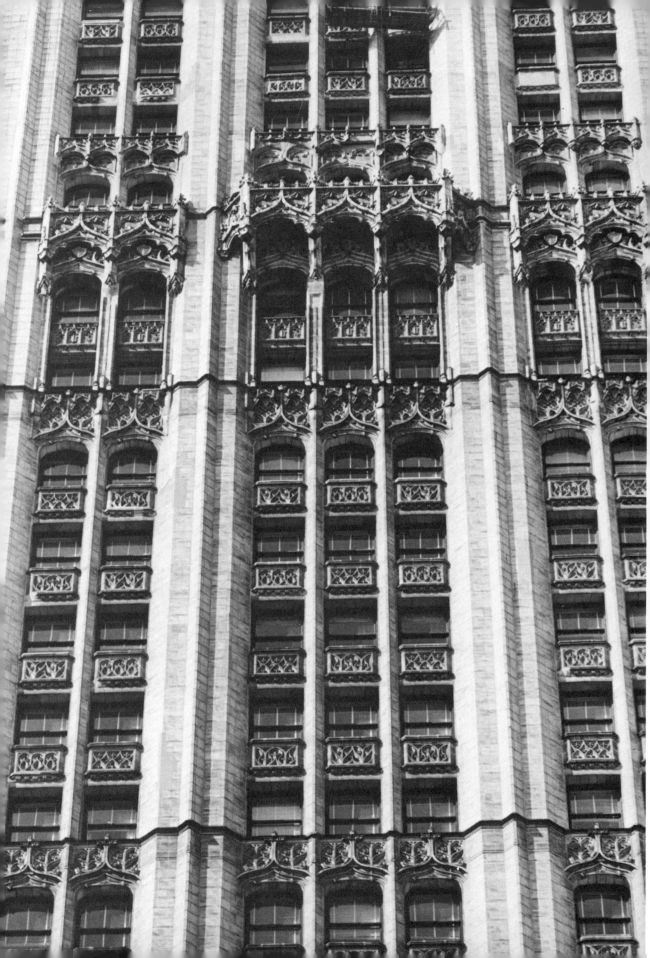

Classical architecture, which is essentially horizontal in emphasis, did not seem to be the answer. Gothic architecture, which emphasizes the vertical, does better, as illustrated by the Woolworth Building designed by Cass Gilbert also in downtown New York. But eventually something else had to happen.

And, of course, as everyone knows, something else did happen.

In June of 1911 I left McKim, Mead, & White to graduate with my class at Harvard and then to see my parents. They had given up our home in Newburgh and gone to Washington, D.C., where they had established themselves in a fine old house on G Street, with studios that they had constructed at the rear. Henceforth the family was never again to live under one roof. My sister, after studying the new craft of batik at Pratt Institute in Brooklyn, eventually settled in New York, and my youngest brother, who was studying to be a landscape architect, moved to Ambler, a suburb of Philadelphia, where his wife became head of a school of horticulture. I lived at home, working for architects in Washington on several occasions. But most of my time was spent in the Boston area, including two years of graduate study at Harvard in order to qualify for the degree of Master of Architecture in 1915. There followed employment in the Boston office of Cram & Ferguson.

I took it for granted that I would be making drawings of Gothic structures, since Cram was famous for his Gothic churches. To my surprise, the drafting board to which I was assigned was in a room where everything being designed seemed to be in the classical manner. A colonial chapel for Wheaton College and a gateway to the Boston Common at the foot of Joy Street were two jobs on which I helped in the preliminary and working drawing stage under Alexander Hoyle, who, with one or two others, had a thorough knowledge and sensitive feeling for the classical tradition.

Mr. Cram would come in once or twice a day, take a quick glance at what was on the boards, and if he deigned to say anything, it would be to remark, "a completely artificial style," and pass on. More than likely, he was on his way to the "Saints," who resided in a separate, rather closed-off room. The Saints, as they were called, were three men engaged in work on the Cathedral of St. John the Divine in New York, a major portion of which was then under construction. In this room was a model in three dimensions showing what this great building would look like when completed.

Cass Gilbert's Woolworth building, 1913, in downtown New York shows how the vertical emphasis of Gothic architecture was better fitted to the skyscraper than classical principles whose essentially horizontal expression was unreasonably strained by the challenge of the tall building. Photograph by Martin Munter.

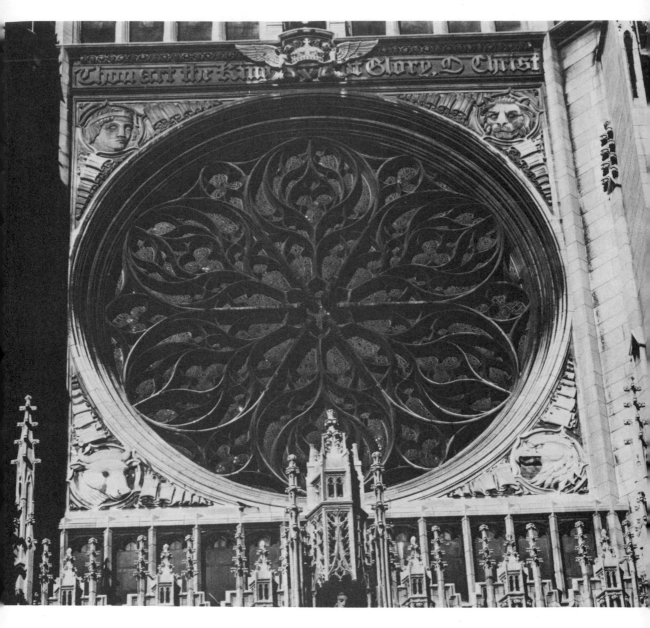

Experience in the Boston office of Cram & Ferguson in 1915 (where one room was given over to "the Saints" who were working on the design of the Cathedral of St. John the Divine in New York) gave me insight into the complexities of a style based on the religious architecture of the Middle Ages. St. Thomas's Church on Fifth Avenue, designed by Cram & Goodhue in 1911, is an excellent example of Ralph Adams Cram's talent for traditional forms, innovative spaces, and beautiful details. Photograph by Martin Munter.

It was the custom once a year for all the employees at the office to be invited to Mr. Cram's home in the suburbs on a Sunday afternoon. After being introduced to Mrs. Cram and having been shown around, one of the older men was bold enough to ask, "How does it happen, Mr. Cram, considering your belief in the Gothic of the Middle Ages as the only architecture worthy of our respect, that you are living in a colonial house?"

"You should know by now," Mr. Cram replied, "that architects are not accountable. You see that little nondescript medieval-looking house down the road. Well! That is where the great authority on colonial lives—Chandler."

How could I have imagined that one day I would be taking part in the renovating and enlarging of one of Joseph Everett Chandler's creations, the Duxbury Library? That he was an authority on colonial is borne out by the fact that he was the author of a book on this subject, entitled *The Colonial House*.

E ver since the Renaissance, which was the revival of Roman architecture in Italy, architects and writers have been examining and recording their discoveries of the ancient world. More recently, a vast amount of recorded data has been accumulated in books and magazine articles accompanied by photography, covering the important examples from all countries and from all periods of time—a chronicle of civilization from the past to the present. Now all this source material is available to the schools, the profession, and the public. Nothing, at least on such a scale as this, had ever happened before, and the result was unprecedented. Previously, changes kept occurring, of course, but they were gradual, evolutionary changes even when there was a revival. At any one time and place, there had always been an accepted idiom or prevailing style that grew out of what had gone before and led to what followed.

In the year 1893 (to use the Chicago Fair again as a convenient date), and for a generation or more thereafter, there was not just one style or even two, but all styles from which to pick and choose.

The period of eclecticism, as it is called, had arrived.

Now a client could go to an architect and say, "I wish to have a house in Norman Provincial, or Early Colonial, or Greek Revival." Or a committee might say, "We are going to build a church, and we like that church you designed on Mount Vernon Street." And the architect might say, "Yes, that is Italian Romanesque, and if you'll step into my library, I will show you illustrations of a number of examples of churches in North Italy, some with free-standing campaniles, some without. You can choose." Not that he would expect to make an exact copy; only that he would expect and be expected to adhere to some definite style. Any building of any pretentions must have an historic style label to pin upon it.

Some architects liked one style, some another. Occasionally no preference was admitted, and the claim was made that the designer could work equally well in any style one could name.

My employment in the office of Cram & Ferguson was terminated by the First World War. I enlisted in the Navy and was commissioned by the Bureau of Yards and Docks to report to the Submarine Base at New London, Connecticut, where I remained until well after the war, engaged in inspecting buildings under construction.

Before these projects and the process of being released from the Navy were completed, I was already back in civilian life and working in New York. That is where I was when my sister Lydia returned from her war experience in Europe. She had enlisted in the armed services in a newly formed group of women with art or craft training who served in the American hospitals in France doing what was called "occupational therapy," the purpose of which was to interest wounded soldiers in something to occupy their time and help them in their recovery. One of the participants, Marjorie Conant, from Boston, became her friend, and on their return, they shared a studio in New York. Thus it was I came to know Marjorie, and in 1924, I married her in Paris.

The women in the two families were the ones who went to war. The brothers, James B. Conant and I, remained on this side of the Atlantic. If actual warfare is exciting, and there are those who seem to think it is, we missed it. There was still something we could contribute, and in the case of my brother-in-law, it was something significant.

After several months of work in New York I set off for a trip to Europe, which was regarded as a desirable last step in the preparation of an architect. Coming back to the United States, I received a call to go to Atlanta to teach in the Department of Architecture at the Georgia School of Technology.

This was in 1922, the year of the Chicago Tribune Tower International Competition, won by Hood & Howells of New York. From an historical view it marked a turning point, and was significant, not because of the design that won, but because of the design that placed second, which some thought should have been awarded the prize. This design was by Eliel Saarinen from Finland, a man who had never been in this country and was totally unfamiliar with the problem of city buildings rising upward towards the sky. The astonishing thing about the quality of Saarinen's design was that there was no trace of historical precedent, no style with which to identify it. It was such a masterpiece of daring and skill that its influence was far greater than the jury's selection, which was built four years later.

Naval service during the First World War did not keep me from the continuing study of architecture. Photograph of the author by Bachrach in 1919.

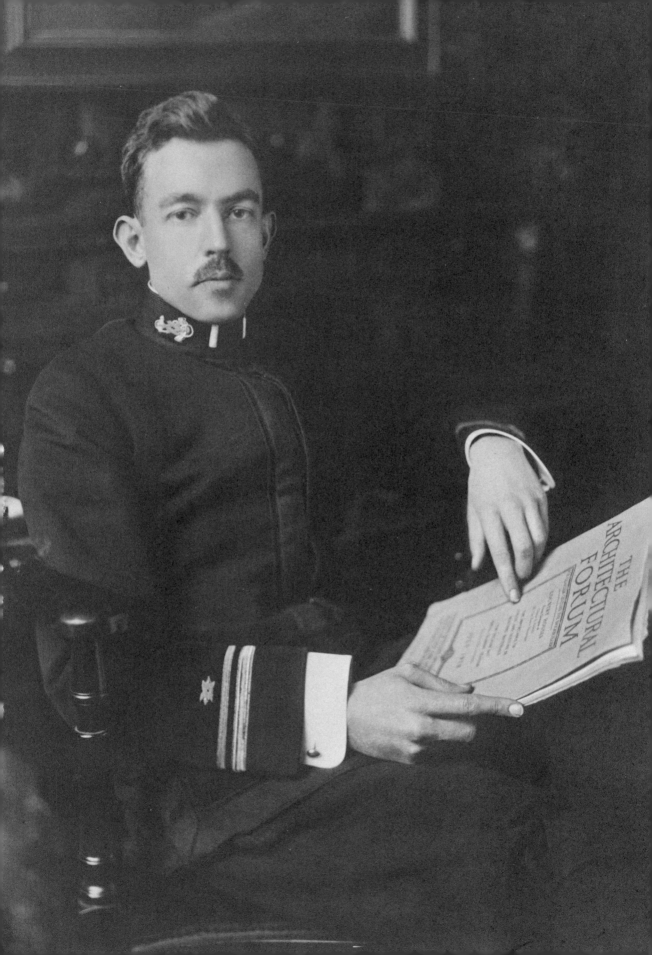

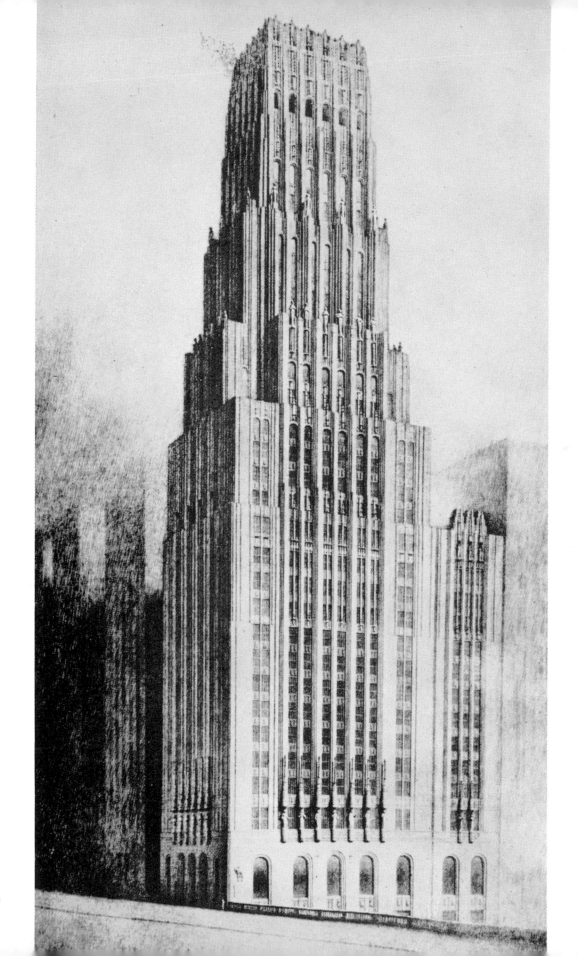

The concept behind Saarinen's design was not a new idea. Giving up reliance on historical styles and creating a new architecture had been preached and practiced by Louis Sullivan,[1] whose Transportation Building at the Chicago Fair was the one building not carried out in the prevailing classical tradition. It was a notable achievement without precedent, but Sullivan was way ahead of his time and died a disappointed man. His protégé, Frank Lloyd Wright, continued to carry the torch, but he too was looked upon askance and had little influence, although he was admired in Europe long before his genius was recognized in this country. The fact is that it is to Europe that one must turn for the beginnings of a revolution in art and architecture, to the Bauhaus in Germany, the school headed by Walter Gropius, and to the CIAM (International Congress of Modern Architects), which included such well-known names as Le Corbusier, José Luis Sert, and Mies van der Rohe.

Saarinen's design in the Chicago Tribune Competition was a precursor of things to come. There was no sudden spread of a strange, unfamiliar growth, but the seed had been sown.

Left: In 1922, a seminal year for modern architecture, Eliel Saarinen's design for the Chicago Tribune Tower was awarded second place in an international competition, which was won by Hood & Howells. Saarinen's design showed no trace of historical precedent. Courtesy Cranbrook Academy of Art Museum.

Photograph on page 28: In the 1930s, students in American architectural schools were changing the way they attacked design problems. Modern solutions to design exercises could be found in many student portfolios, but some of these still displayed traces of Beaux Arts influence in presentation techniques, as in this student scheme for an aquarium by Ieoh Ming Pei about 1937. Courtesy MIT Historical Collections.

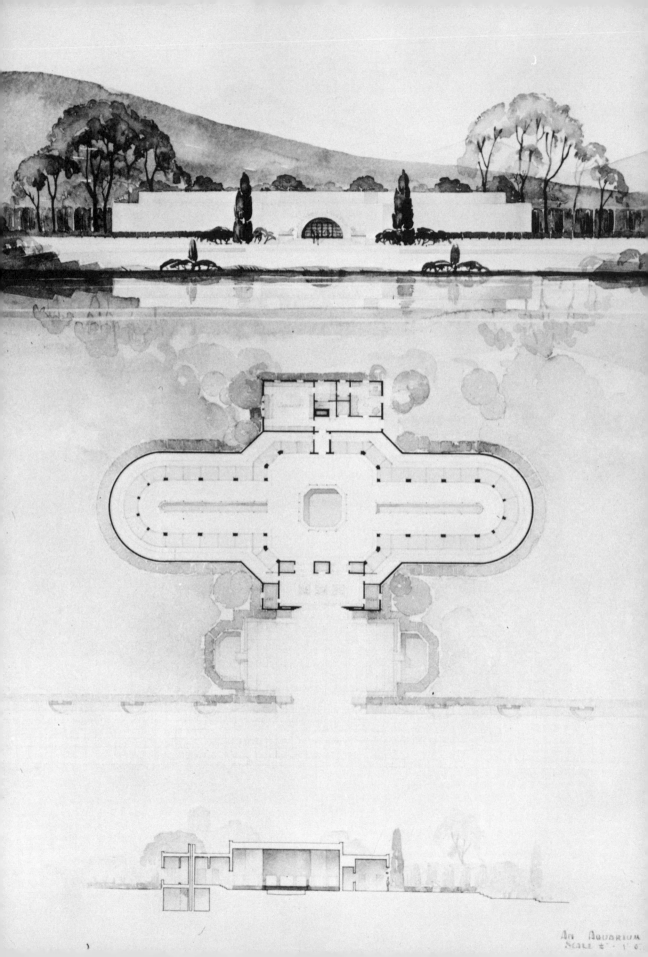

2. The First Stage of Change

The call I received in the summer of 1922 offering me a position in the Department of Architecture at the Georgia School of Technology came from James L. Skinner, with whom I had been traveling in Europe. On his return to the United States he had been summoned to take the place of Francis P. Smith, the head of the department, who had resigned. I agreed to accept, with the understanding that, among other assignments, I would be allowed to teach history.

Georgia Tech was one of the first institutions in the South to establish a full course in architecture. Arriving at the beginning of the fall term, we newcomers, with no prior experience in teaching, were confronted by a difficult situation that was to demand all our energies for some time to come.

Three years after our arrival, James Skinner, who had persuaded me to join him in Atlanta, gave up his position to practice architecture in Miami. In taking his place as head of the department, I was presented with the problem of finding additional teachers to carry on the work of a fast-growing school.

There was no cause for concern in one respect: no one at this time was suggesting any fundamental change in the teaching of design, the subject of utmost importance in a school of architecture. In accord with other American schools of the 1920s, we held to the objectives and methods derived from L'École des Beaux Arts in Paris. It was a highly competitive system in which student work at Georgia Tech continued to receive favorable recognition in competition with designs by students in other schools. The styles of the past were made use of, as they were by schools throughout America and by all architects, with one or two notable exceptions.

Of course, preparing students for a professional lifework such as architecture demands a great deal of time and effort on the part of the teacher. Nevertheless, some members of the faculty, myself included, found time to design campus buildings. This is not unusual and is considered justifiable, provided the outside work is not allowed to interfere with teaching as the prime responsibility. In fact, it is often encouraged, on the assumption that students will benefit because of the teacher's direct participation in practice.

It was the President of Georgia Tech who, with the approval of the Trustees, asked us to design a group of dormitories[1] and a dining hall.[2] There was never any uncertainty about style; we simply continued with what had been adopted by our predecessor in the most recent buildings, a style based on the architecture of English college buildings of the 15th and 16th centuries.

The affairs of the department seemed to be under control, and in our naïveté, the Florida boom, over the horizon, was looked upon as a sign that prosperity had come to stay.

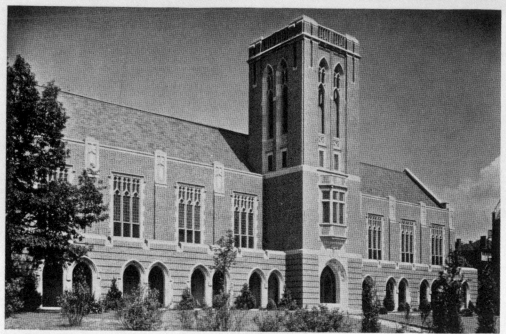

Tebbs & Knell Photos

GEORGIA SCHOOL OF TECHNOLOGY

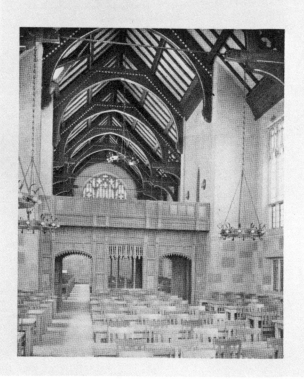

This dining hall will connect through arcades with two dormitories, Harris Hall (shown on the following page) and one to be constructed in the future. The "rood screen" serves as the vestibule dividing the hall into two well proportioned rooms. The space above the screen is used as a special dining room. The ceiling is sound-absorbing and heat-insulating

DINING HALL
ATLANTA, GEORGIA
HAROLD BUSH-BROWN, ARCHITECT

When our firm was commissioned to design a complex of dormitories and a dining hall for Georgia Tech, we had no feeling of uncertainty about style. We followed the campus precedent—a style based on 15th- and 16th-century English college buildings. Courtesy Architectural Forum, *June 1931.*

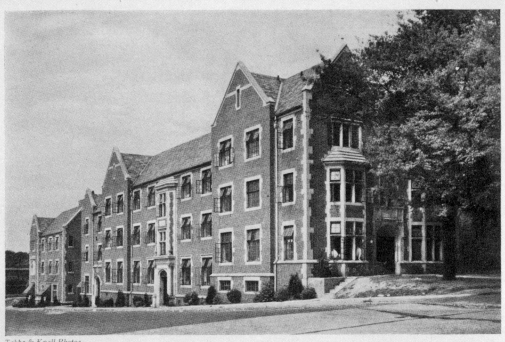

JULIUS BROWN DORMITORY
ATLANTA, GEORGIA
SKINNER, BUSH-BROWN AND
STOWELL, ARCHITECTS

Two dormitories designed to house students efficiently and economically. Rooms average approximately 150 square feet, each accommodating two students. This area includes two closets approximately three feet square. Furniture consists of double-decker pipe-frame beds, two desk tables and chairs. Large stock casement windows give adequate light and ventilation

N. E. HARRIS DORMITORY
ATLANTA, GEORGIA
BUSH-BROWN AND STOWELL
ARCHITECTS

It was not until 1929, on the occasion of an official visit from Welles Bosworth of MIT and Roy Childs Jones of Minnesota, representing the ACSA (Association of Collegiate Schools of Architecture), that we received a shock to our complacency. A sophomore year requirement of a drawing that made use of the elements of the classical orders to create a composition was criticized as being unrelated to the functional problems of the day and hence of no value. It could be argued that an exercise in composition is a matter of esthetics in which the consideration of function is irrelevant. However, to insist that the student use forms with which he may not be sympathetic, for whatever reason, would seem to be wrong. On that basis the criticism had validity, and the requirement was dropped from the curriculum. While the emergence of this issue was a sign of the changing attitude, I doubt that any of us at that time could have had a clear premonition of the drastic nature of events soon to occur.

Our visitors were mainly concerned with the insufficient amount of time allotted to the course in architecture and to the inadequacy of classroom space. The four-year course has since been extended to five or six years for a Bachelor of Architecture degree in all ACSA schools. And the space problem was, unfortunately, not unique to Georgia Tech. It seems that wherever they went on their tour of North America, they found schools of architecture in attics, or scattered about the campus, or as was the case with us, located on the top story of another department's building. In no case was the architecture department adequately housed in a building of its own that was planned to meet its specific needs.

Another occurrence of the year 1929 that affected everyone was the financial crash, and the following three or four years marked the bottom of the Depression. This was just when we were graduating the largest classes in the history of the school. Those who were awarded a degree were to find that they had spent four years in preparing for a profession that was especially hard hit. There were no jobs; certainly there were none in the offices of Atlanta architects.

It may be nothing more than a coincidence, but in reviewing the events of these times, I am impressed by the fact that during the Depression years a noticeable change in outlook began to emerge in the way in which many students attacked their design problems. To illustrate what was going on, I will recount the experience of one student who graduated in 1933.

It was customary to invite one or two practicing architects to judge student work along with members of the faculty. Drawings of a particular class were collected on a set date and put up on the walls. Then the jury appeared on the scene to examine the designs, express opinions and preferences, and thus help in determining grades. One of the men frequently called upon to serve on a

In the 1930s at Georgia Tech, I had no idea that the gradual changes we were experiencing would turn into an architectural revolution. Photograph of the author in the thirties.

jury was Francis P. Smith, the former head of the department, who never failed to respond. Recognizing the talent of one of the students, Smith said that he wished to recommend him for a scholarship so that he could continue his studies in graduate enrollment at the University of Pennsylvania, which was his alma mater. Smith emphasized that the application must include examples of traditional, well-defined styles, preferably classical. To our surprise, not a single example of classical or any historical style by the student could be found in the vault where all current student work was retained—not even the required analytique. (Although this was found later, it was too late to be of any use.) In other words, Hugh Stubbins, the young man in question, even in the early 1930s, was a modernist, an avant garde.

The end of this tale is that Hugh went to Harvard, where he received a Master of Architecture degree in 1935. In 1940, Gropius, the new chairman of the department, invited him to return to Harvard as his assistant in the graduate school, and in 1953, upon Gropius's resignation, Hugh served as chairman of the department for a short time. Eventually he gave up teaching to devote all his time to a growing practice.

I think this episode shows something about architectural education in general and the initiation of change in particular. Unlike students in many other branches of learning, the architecture student is given a great deal of freedom in what he chooses to do and how he chooses to express himself. In addition, students can help in setting the pace in the first stage of a revolution.

"Revolution" may not be the right word to characterize what was going on in the 1930s. There is no doubt that a change was taking place in the period before World War II, but it was a gradual change without the accompaniment of violent emotions. The real revolution, as I experienced it in Atlanta, was to come later, after the war.

In the meantime, as we have seen, students could try their hands at modern design if they had the courage and the skill to do so. Abandonment of tradition, however, came slowly.

The Department of Architecture at Georgia Tech continued to use programs issued by the Beaux Arts Institute of Design (BAID), a national educational venture inaugurated by Americans who attended the École in Paris and who adapted the French system for architecture schools in the United States on a coordinated, national basis. Student designs were selected and sent to New York to be judged by well-recognized architects and teachers, who graded the entries from the participating Eastern, Southern, and Midwest schools. In 1940 Georgia Tech was awarded the medal for the best average rating on the previous year's submissions. Soon after this, the Beaux Arts Institute, contrary to custom, held a national judgment and exhibition in Atlanta.

Not long thereafter, a short vacation in my wife's family summer home in Duxbury, Massachusetts, gave me the opportunity to investigate possible applicants for teaching positions recommended by the Harvard and MIT architecture schools. A member of the Harvard faculty, whom I had known when I was a student, invited me to lunch along with a group of his fellow teachers. During the luncheon, I remarked casually that the Beaux Arts

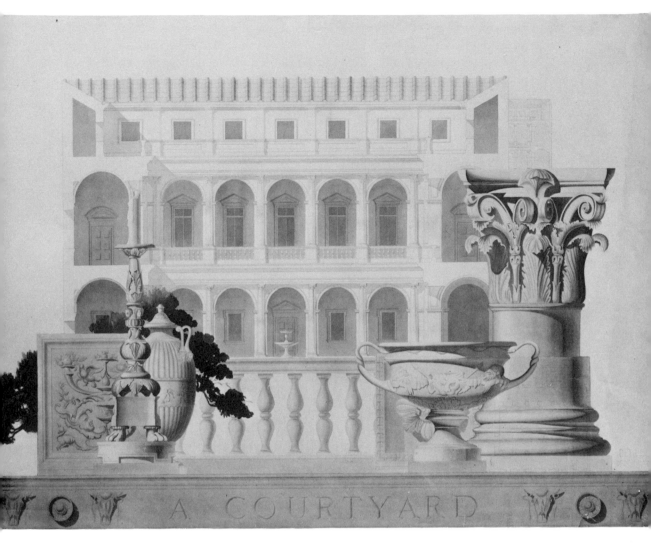

While students who wished could try their hands at modern design, abandonment of tradition came slowly, and Georgia Tech continued to use programs issued by the Beaux Arts Institute of Design. W. C. Thomson's analytique, "A Courtyard," about 1940 was probably the last true analytique problem done at Georgia Tech. Courtesy Paul Heffernan, Director of the College of Architecture, Georgia Tech.

Institute of Design had held a national judgment in Atlanta and that without exception all the drawings sent in by various schools were modern in design. My friend looked at me narrowly, and turning to the others, he said in a loud voice, expressing something between astonishment and disbelief, "Did you hear that?" I said that I had found it hard to believe myself, but that it was true.

While the country was recovering from the Depression in the 1930s, the School of Architecture at Georgia Tech was beginning to grow again. Jack Rowland, who headed the advanced design curriculum, was encouraging students to use their imaginations in creating original designs. He was a stimulating teacher, but he unfortunately left us to set up a practice in North Carolina.

At this juncture I learned that Paul M. Heffernan, who had won the Paris prize, was coming back from Europe after almost three years of working in a Paris atelier and traveling throughout Europe. I met him soon after his arrival and persuaded him to come to Tech to take charge of senior design.

Heffernan was an ardent follower of the Beaux Arts, and not surprisingly, he became very interested in the Beaux Arts Institute of Design. But the influence of the institute was declining. Although the institute accepted the modern style, enthusiasm for participating in the BAID program seemed to be fading. Decentralization—holding judgments and exhibitions in places other than New York—and even changing the name, dropping the words "Beaux Arts," proved to be ineffective. What happened seemed to be countrywide in scope. One school after another withdrew from the National Institute for Architectural Education, as it was now called. The fact is the Beaux Arts influence was on the decline and was being supplanted by an upsurge in influence coming from the Bauhaus.

Harvard had taken little interest in the Beaux Arts Institute experiment. After the arrival of Gropius, the school automatically became tied to the Bauhaus philosophy. Apparently, anything with the title "Beaux Arts" was looked upon as hopelessly reactionary.

The Bauhaus had a right to claim leadership in Europe in the abandonment of historic styles, and Gropius, its founder, in coming to this country, became the outstanding spokesman and champion of the cause. But no one person or school could claim exclusive proprietorship of the spread of ideas it embodied. Modern was taking hold on the educational front, and the personal incidents recounted above prove how widespread the movement had become. The conflict between the Bauhaus and the Beaux Arts was a conflict in objectives and methods of teaching. The growth and spread of modern in schools of architecture was becoming a nationwide movement and was to a large extent independent of this conflict. In other words, it was not a case of which schools were going modern and which schools were not. They were all going modern whether or not they continued with the Beaux Arts Institute of Design

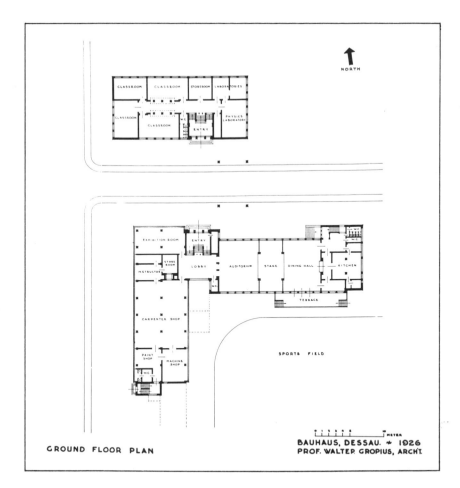

CLASSROOM CLASSROOM STOREROOM LABORATORIES
CLASSROOM CLASSROOM M.C. PHYSICS LABORATORY
ENTRY

NORTH

EXHIBITION ROOM ENTRY
STORE ROOM LOBBY AUDITORIUM STAGE DINING HALL KITCHEN
INSTRUCTOR M.C. W.C.
TERRACE
CARPENTER SHOP
SPORTS FIELD
PAINT SHOP
MACHINE SHOP
W.C.

GROUND FLOOR PLAN

BAUHAUS, DESSAU. + 1926
PROF. WALTER GROPIUS, ARCHT.

Left: The revolution in American architectural education began in 1937 with the arrival at Harvard of Walter Gropius, founder of the Bauhaus in Dessau, Germany. Plan of Bauhaus by Walter Gropius. Courtesy The Architects Collaborative.

Below: Gropius's influence spread to all schools of architecture, and soon it was not a question of which schools were going modern, but how far they would go in their acceptance of the Bauhaus philosophy. Student scheme for a Brick and Tile Company Building by Ieoh Ming Pei about 1938. Courtesy MIT Historical Collections.

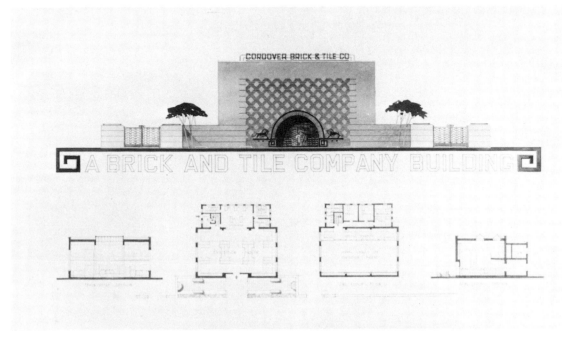

CORDOVER BRICK & TILE CO.

A BRICK AND TILE COMPANY BUILDING

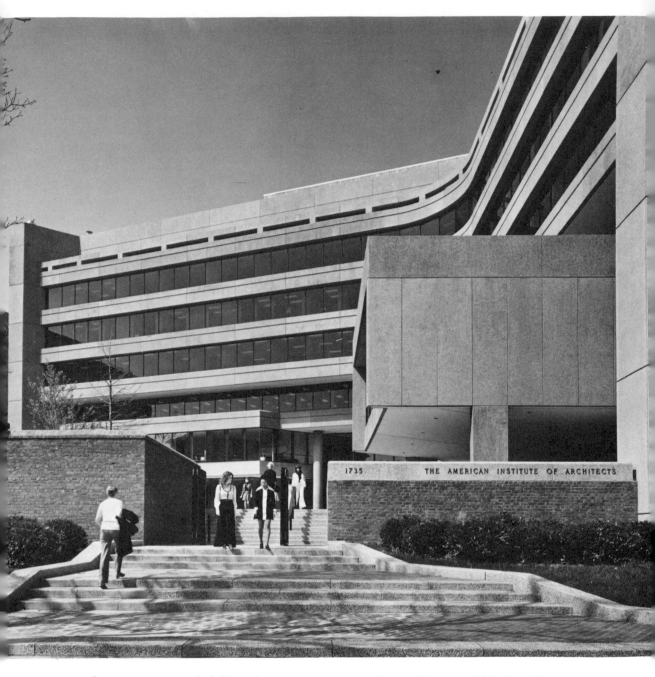

Gropius was an early believer in group or team practice, and he named his firm The Architects Collaborative (TAC). One of TAC's recent buildings is the new headquarters for the American Institute of Architects in Washington, D.C. Photograph by Ezra Stoller.

program. There were still doubts about exactly how far one should go in accepting the Bauhaus philosophy, which brings us to the question of just what were Gropius's beliefs: What was he striving for, and what methods did he advocate to achieve his objectives?

What was it the Bauhaus stood for which brought it into such prominence and caused it to become dominant in the education of architects in America?

At a Chicago dinner in honor of Gropius in 1953, Mies van der Rohe had this to say: "The Bauhaus was not an institution with a clear program; it was an idea, and Gropius formulated this idea with great precision. Only an idea spreads so far."

There is no doubt that the two systems, that of the Beaux Arts and that of the Bauhaus, were at opposite poles in their philosophy and in their teaching methods. The tradition of the Beaux Arts was the search for the ideal of formal and elaborate beauty, and this could best be encouraged by the glorification of the individual through the granting of honor awards. The Bauhaus was dedicated to producing buildings that enable maximum service, taking full advantage of what the machine has to offer in achieving simple, unpretentious but efficient results.

Gropius was imbued with the idea that we should not seek glory for ourselves, but should strive for the betterment of mankind. This, he thought, could be accomplished by carrying out such projects as group housing. In our individual relations with each other there should be cooperation, not competition and rivalry. Nothing could illustrate this belief better than the name adopted for the professional firm he formed and headed in Cambridge, Massachusetts, made up of young graduates of Harvard. It was entitled "The Architects Collaborative," because Gropius refused to allow his own name to be used. Of course, all those within the profession are well aware that The Architects Collaborative meant Gropius. Although Gropius has died, the firm he established continues to operate under the name he gave it. One of its most recent achievements is the design of the American Institute of Architects headquarters in Washington, D.C.

Gropius believed that only through the participation of all the arts acting jointly and cooperatively with industry could the best results be achieved in our architecture. He regarded a thorough knowledge of materials and the ways in which they could be used as essential. And he felt strongly that the only way this capability could be acquired was by on-the-job experience. No architectural school in the country, not even Harvard, could hope to meet all his requirements. The impact of his beliefs still persists.

Photograph on page 40: In 1952, Frank Lloyd Wright was the only architectural master capable of filling the Georgia Tech auditorium. Frank Lloyd Wright, center, the author, left, and Preston Stevens, Jr., student body president, right, on Wright's visit to Atlanta.

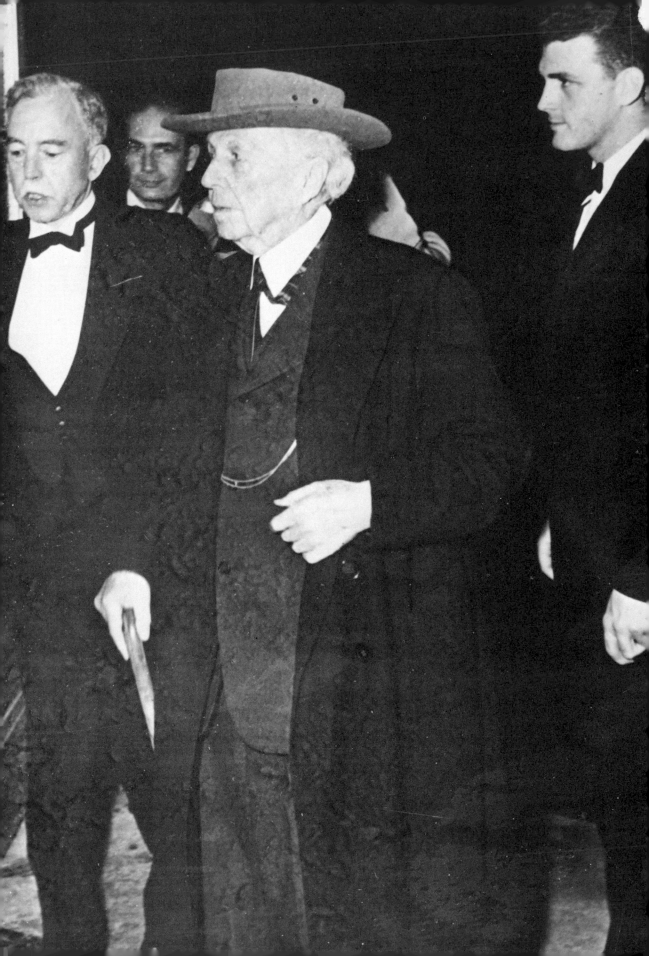

3. Revolution Erupts in Atlanta

In 1945, when peace was declared, we were down to twenty-two students taking architecture. The loss in members of the faculty was equally devastating, and in some cases it was a permanent loss. Three years later, in 1948, the student enrollment had catapulted to 462—far in excess of anything in the past.

As our former students were released from the service and began filtering back to renew their interrupted studies, it was evident that what was about to take place was unprecedented. A new start had to be made in building up a school of architecture.

There were several among our former students who were competent and available to become part-time or even full-time teachers, but, for the most part, it was necessary to recruit from graduates of Northern schools. They brought with them more directly ideas emanating from the avant garde.

Because of the change in direction taken in architectural education during the 1930s, we had thought of ourselves as modern and progressive, along with most other American schools. We had no misgivings about what we were doing, and there was no occasion and no need for publicity. In the midcentury expansion of the school now taking place, however, a different situation arose in our relations with the profession and the public. There was nothing backward about the extreme views being expressed by some of the newcomers on our faculty, and their remarks were being picked up by the professional establishment in Atlanta. The architects of long standing were troubled, some of them outraged, when they realized what was going on. Returning from a brief vacation in 1951, I, as the director, was put on the spot in an interview that came out in the paper: "Don't you teach fundamentals any more?" That meant the classical orders: the Doric, the Ionic, the Corinthian, which originated in Greece, were perpetuated by the Romans, revived by the Italians in the Renaissance, and brought to America by the English about 1700.

My answer was: "Yes, of course; it comes in the history of architecture and everyone is required to take the courses in history."

"But in design?"

"No, we do not insist or even encourage students to use obsolete forms."

"Obsolete forms." That really caused the furor!

I had no prior notion of the amount of adverse publicity that remark would produce. It was bad enough for the school to be in the wrong with practicing architects, without also antagonizing lay members of the community who might be living in reproductions of colonial homes.

I remember a friendly architect who invited me to lunch only to plead with me. He asked me how I thought architectural firms could get along if the

school did not give the students they graduated a thorough knowledge of the classical orders. My answer was that there were enough of the old-timers to do that job, and perhaps, when the new generation came along, they would not have to know the orders because there wouldn't be any.

That is roughly what has happened.

But it was not easy for those of us in education who had to make the decisions. The price one pays for living in a revolution is that you have to be wholeheartedly for it or you are against it, or so it will be regarded. There is no half way about it, no middle ground.

That it was a difficult time for me is indicated by a telephone call that came from someone representing *Time* magazine in September 1951. "I understand there is a conspiracy to try to get rid of you. Can you tell us something about this?"

"No, I cannot, because I don't believe there is any truth in the rumor." As a matter of fact, I had reason to believe it, but I was not going to be drawn into a publicity stunt, and the conspiracy, if there was one, never surfaced.

My outlook was that of a teacher of history with a love for past creations of order and beauty, and the spectacle I saw now was not always to my liking. The two most radical men on our staff were not, as might have been expected, from Harvard, but from Midwestern schools. They had no use for anything in the past, lumping everything together—good, bad, and indifferent—no discrimination, nothing worth saving. Everything that had been was relegated to oblivion.

From another angle, the study of the history of art and architecture eventually led me to the conclusion that there was no question about the need for a revolution or its inevitability. That statement may be difficult to comprehend and calls for clarification. It is based on the fact that the present situation has no parallel in history.

Architecture at all times has been going through a process of change. In the past it has always been a gradual change, with plenty of time for adjustment. Because of the very remarkable recent extensive and sensational discoveries of science and the accelerating application of these discoveries to practical pursuits, the architect and the engineer have suddenly been presented with the tools for doing what their predecessors could never have done. Thus the changes have resulted in an abrupt, complete, and unprecedented break with the past. It was bound to meet with unusually strong resistance on the part of the older, more conservative members of the profession, who were being put in the position of either having to give up their convictions based on their lifelong training and the application of their beliefs or taking a stand and resisting the changes they were not prepared for. It was their resistance and the emotional intensity of opposing forces that we have come to speak of as a revolution.

More specifically, you cannot successfully make a filling station look like a colonial house and you can't make a skyscraper look like a Roman temple or a Renaissance palace. Both attempts have been made, but to continue to do so was found to be ridiculous. Such examples of new kinds of structures being increasingly used were destined to take on a new look, and it was not long before all types of structures were affected by the changing approach to design.

Whatever may be the trials of living through a revolution, life was not dull. Among the younger men who joined our faculty just after the end of World War II were three from the Harvard Graduate School of Design—D. J. (Jim) Edwards, Thomas Godfrey, and Samuel T. Hurst—who, of course, had come under the direct influence of Walter Gropius. They were full of enthusiasm for the new approach to the teaching of architecture. They were in a position to help bring to the school a succession of leaders in the modern movement as guest lecturers and visiting design critics. Among others, the list included Walter Gropius himself; Marcel Breuer, another brilliant Bauhaus man whom Gropius had brought to Harvard; and I. M. Pei, a Chinese-American, who has become one of the country's leading architects.

But the great star in the eyes of the public was Frank Lloyd Wright—the only man capable of filling the huge Georgia Tech auditorium-gymnasium with people eager to hear him speak.

The words of wisdom spoken by our visitors on behalf of change brought to light, if we had not already glimpsed it, that the backers of modern did not always agree with one another. But their message was clear and, on one point, unanimous: there was no longer any place for eclecticism—the reliance on the styles of the past—in the contemporary world.

Frank Lloyd Wright's visit in the spring of 1952 remains vivid in my memory. After his speech at Georgia Tech, he and his wife were brought to our house. Wright's reputation for being outspoken in his criticism, arrogant, and egotistical caused us some concern and speculation on just what to expect. We were pleasantly surprised, therefore, to find them both charming and delightful guests. On entering our living room, where there were two steps down to a lower floor level, Wright remarked that this was something he had always wanted to do. He walked around the room and through the wide-open double doorway into the dining room, examining everything on the walls and voicing praise for what he saw—the silk mural over the mantle by my sister and the many paintings, most of which were the work of my wife. The only other guests, soon to arrive, were the students of the senior class, who grouped themselves on the floor around the "Master," listening intently to what he had to say in an almost continuous flow of words.

That Wright was overcritical cannot be denied—critical of the schools of architecture and of the work of other architects—but, in one respect, the belief

that he was a publicity-seeker without equal may be a misjudgment, I think. It may well be that it was the sensational incidents of his life rather than his self-appraisal as a genius that were mainly responsible for his fame. I understand that at one time he was so plagued by the press that he engaged a newsman full-time to keep other newsmen from bothering him. No other architect's name is known nationally by the American public. He is the one great exception, and that this is so is not all due to his intent to make it so.

The enormous relief that comes from seeing a war end was soon to evaporate because of the problems that were to trouble us in the post-war era. The numbers of students coming back plus the increase of students coming in as freshmen made it obvious that there would not be enough room to take care of them.

There had never been an overall study of how Georgia Tech, which was located only about a mile from the center of Atlanta and which was being hemmed in on all sides, should or could expand. What was needed was a master plan. The administration seemed incapable of visualizing the full extent of this need. However, authority was granted for a limited study of the central portion of the campus. The first step was taken by engaging R. L. Aeck, an alumnus, to make drawings and a model of the central educational area. The purpose of this study was to determine where future buildings would be located and how they would be served by roadways, walks, and parking lots.

Outside the area covered by this study there were dormitories to be built, and the Athletic Association was prodding us for prompt action on several undertakings, including a modern addition to the stadium or grandstand, one of the first of the new projects to be completed.[1]

As the student body grew and as the demand for new buildings increased, those of us who were serving both as teachers and as architects were confronted by a dual problem. We needed additional space to carry on the architecture courses, and it was necessary to employ personnel and have an office in which to create the designs, make the drawings, and write the specifications for the new campus buildings.

These circumstances required unusual measures. Wherever there was a building nearby the campus that was about to be torn down, we claimed it. Most of them were old wooden houses ready to fall apart, but the situation was so desperate that we moved in without waiting for repairs. Each house, as it became available, was allocated to a group of students taking design, and they were told that they would have to get along with it as best they could, spending whatever time they chose restoring it for their use. I was surprised to see how successful some of them were in making their work area habitable and, in some instances, even delightful. I sensed a more-than-usual *esprit de corps* within the individual group, whether because of isolation, independence and freedom from restriction, or the satisfaction that comes from creating one's

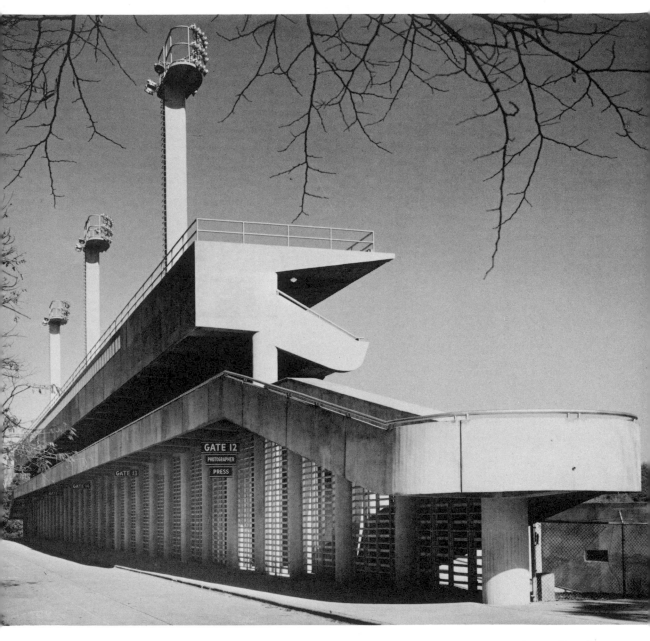

One of the first examples of modern architecture in Atlanta was the addition to the stadium by Bush-Brown & Gailey, architects, Paul M. Heffernan and R. L. Aeck, associate architects.

own environment or from a communal feeling in group action. In fact, any combination or all of these may be the explanation.

One of the houses recently purchased was across the street from the School of Architecture, and as it was large enough and in fair condition, it became the office and drafting rooms of the three-professor firm of Bush-Brown, Gailey, & Heffernan, architects for most of the new Georgia Tech buildings. Our staff included some other members of the faculty on a part-time basis, and we also engaged supervisors and draftsmen, most of them Georgia Tech graduates, on a full-time basis.

In the central educational area, three proposed buildings had priority: the library, a building for the School of Architecture, and a new building for the textile department. Although it was the last on the list, the Textile Building was the first to be built, only because the Southern textile industry came forward with the necessary funds.[2]

T here was one overriding issue that applied to all three buildings: should they be traditional in design, conforming to the style of former buildings on the campus, or should they be of modern design in defiance of precedent and with disregard for the opposition? As far as those of us who had been asked to serve as architects were concerned, there was only one answer.

In discussing this subject with the administration, they reacted in the usual manner, as was to be expected: they did not like modern architecture. However, in the case of the Textile Building, which was to be somewhat isolated, the thought expressed was: "Well, a textile engineering building is nothing but a factory, anyway, so what does it matter?" As for the School of Architecture, the idea seemed to be: "Let the crazy architects have what they want; after all, they are the ones who will have to live with it." But when it came to the library, it was another matter. The librarian was adamant in her resistance to change. The major contributor, for whom the building was to be named, was pictured as very unhappy at even the suggestion of modern. Furthermore, as this building was to be centrally located, it would be near the older buildings with the accepted traditional style. So went the argument advanced by the conservatives. And that meant almost everyone.

Fortunately, plans for the library were postponed, and we were able to concentrate on further studies for a building for the architecture department. It was at just this strategic moment that the unforeseen happened. The General Education Board of the Ford Foundation in New York decided to promote cultural education in the Southeast as a worthy cause and selected the Georgia Institute of Technology's School of Architecture as the recipient of a fund for an expansion program, with the understanding that the state of Georgia provide matching funds. Provision was made so that our recommendations for a graduate course in architecture, a curriculum in city planning, a course in

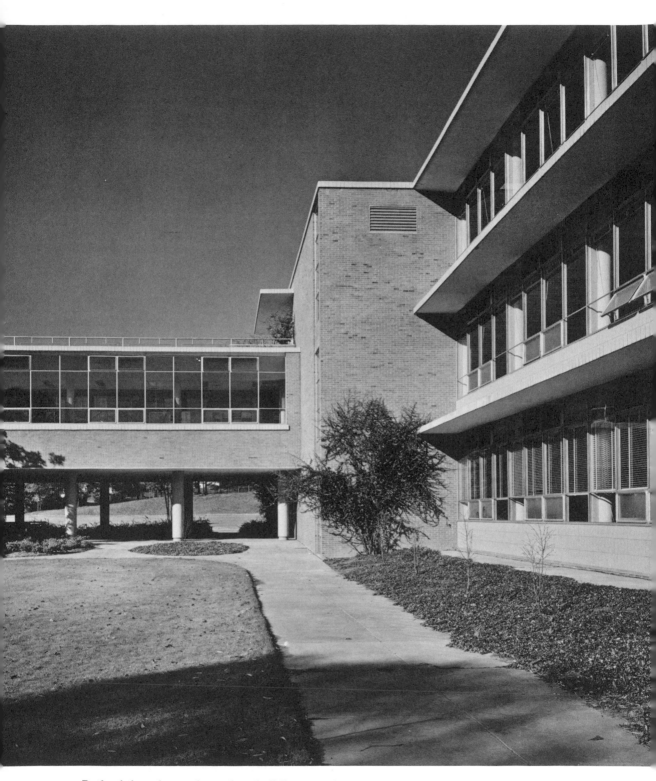

Both of the other early modern buildings on the Georgia Tech campus were designed by the three-professor firm of Bush-Brown, Gailey, & Heffernan, including the School of Architecture completed in 1952. Photograph by Joseph W. Molitor.

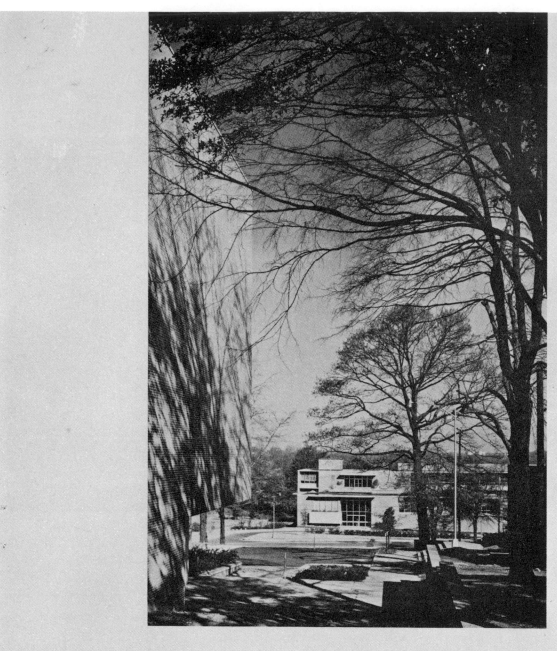

Architecture Building

client	Georgia Institute of Technology
location	Atlanta, Georgia
architects	Bush-Brown, Gailey & Heffernan

National architectural magazines were eager to publish the Georgia Tech buildings, indicating an accelerating emphasis on modern design. Courtesy Progressive Architecture, *July 1955.*

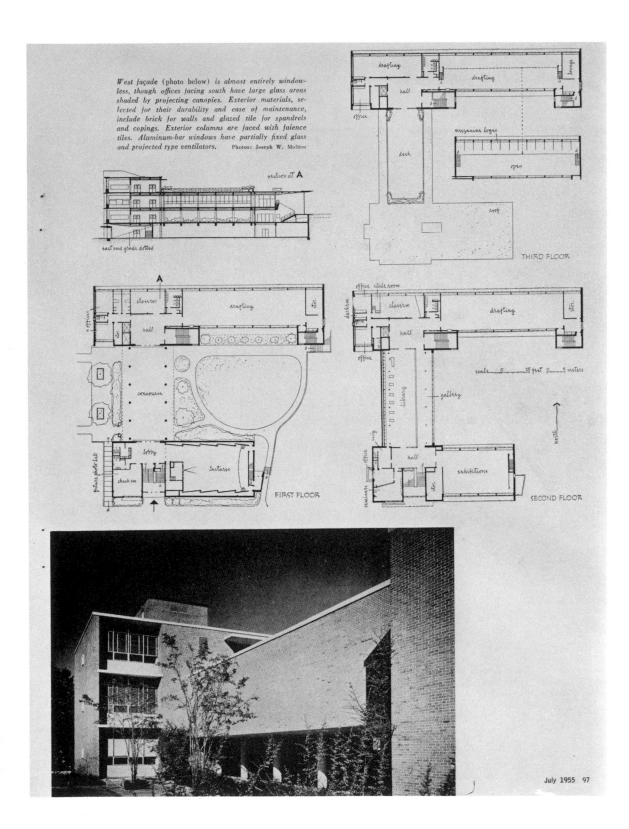

West façade (photo below) is almost entirely window-less, though offices facing south have large glass areas shaded by projecting canopies. Exterior materials, selected for their durability and ease of maintenance, include brick for walls and glazed tile for spandrels and copings. Exterior columns are faced with faience tiles. Aluminum-bar windows have partially fixed glass and projected type ventilators. Photos: Joseph W. Molitor

section at **A**

east end grade dotted

THIRD FLOOR

FIRST FLOOR

SECOND FLOOR

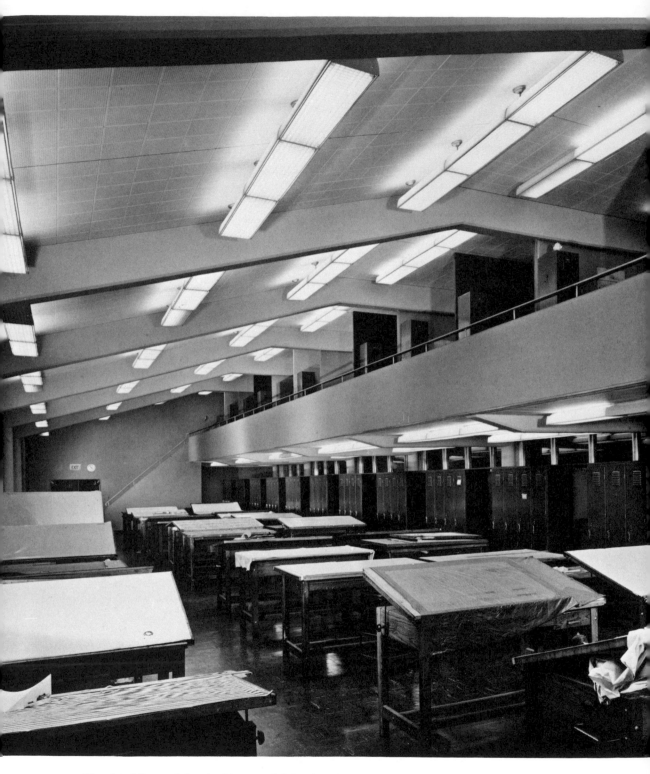

The third floor of the Architectural School is almost entirely devoted to a large drafting room featuring bilateral lighting and a mezzanine with individual study cubicles. Photograph by Joseph W. Molitor.

industrial design, research needs, and space for exhibitions could be realized. The funds could not be used for buildings. But without a building there could be no expansion.

Under these circumstances, it was not surprising that we were allowed to go ahead with revised plans for a new building so that the requirements of this program could be implemented. In so doing, we became a unique example of an architecture school that was completely housed in a thoroughly contemporary building designed by members of the faculty who occupied it.

The building for the School of Architecture was completed, dedicated, and put to use in 1952.[3] While it was being built, we were at work on the library, with all its problems of changing requirements and disagreement on the character of its external appearance. The issues were finally brought to a head following a suggestion that we invite an authority on libraries—John Burchard, Dean of the Humanities at the Massachusetts Institute of Technology—to come to Atlanta for consultation. Two days after his arrival, everything was settled amicably, even in the matter of style. The concession on this question, after a long drawn-out battle, seemed to eliminate any further opposition to modern as the accepted mode on the Georgia Tech campus.

As far as the library goes,[4] there were no further insurmountable troubles with the drawings, and no more than the usual trouble with the construction of the building, which was completed two years later.

That these buildings were of more than local interest is borne out by the fact that all three of the nationally distributed architectural magazines seemed eager to publish illustrations and comments on our work. I feel sure that it was their championship of the modern movement, concentrating on publicizing the many examples of the changing aspect of architecture, that had a great deal to do with accelerating the trend towards modern design and with bringing the architectural profession throughout the country into a common viewpoint. It was not long after the latest buildings were constructed that the hard-line traditionalists had withdrawn or been converted. At least, they were no longer in evidence.

Although those of us who were serving as architects enjoyed providing the overall guidance in the design of the buildings, our primary involvement and major responsibility were in the teaching of architecture. And it is time now to return to that subject.

I recall an incident that relates to one of the unusual methods used to teach design in schools of architecture: giving a student the opportunity to explain and sometimes to defend his solution of a problem.

Before we had a building of our own and were still on the top floor of the Physics Building, I invited a newly appointed dean to attend a judgment, as he said that he wished to become acquainted, through personal contact, with what was going on in the various schools and departments now under his jurisdiction. As one of the designs was being examined, an outspoken member

of the faculty strongly criticized one aspect of the drawings before us, at which the student disagreed and defended his work with equal vehemence. It took some calming down by other faculty members to bring the argument to a close.

Later, as I accompanied the dean out of the building, he remarked that although he had taught in the department of English for many years, he had no idea that anything so contrary to the usual methods of teaching was taking place on the Georgia Tech campus. This was not said in a spirit of censure. At least, I did not so interpret it—only in wonder.

It is true that design becomes so engrossing and success in achievement so important that some students become overemotional, and because of their absorption with their creative efforts, they are apt to neglect their other studies. There was an instance of a student doing very well in design, but failing math, not just once, but two years in succession. It seemed that if he failed again, he would have to leave. His math teacher, who happened to be head of the department, said that he was hopeless, and he added that most architecture students were mentally deficient. I persuaded the student to drop design for a year. The outcome was that he made an A in math both terms. After that, I heard less about mental deficiency.

A further indication of the student's concentration on his work in design and the importance that he attached to it came to my attention when I learned that airplanes coming into Atlanta from the north after sundown found the newly built architecture building a dependable and easily identifiable object on which to focus. This was because the drafting rooms were on the north side of the building; the wall was mostly of glass, four stories high; and at least one or two stories were always a blaze of light well through the night as one group of students or another worked to have their presentations ready to submit to the jury on judgment day.

My last few years in Atlanta were full of interest, accompanied by a feeling of satisfaction that comes when, after a long period of uncertainty, everything seems to have turned out for the best. Moving into the new building in the summer of 1952 brought together for the first time under one roof not only all the elements of the educational programs in architecture, but also the related new programs of industrial design and city planning.

The building contained an auditorium large enough to seat everyone in the school when there was an occasion of general interest. The space over the auditorium was intended for exhibitions and judgments. There was a school library that occupied a central position, in recognition of the need for easy access to books and documents, especially by those engaged in the creative work of design. When the new Georgia Tech Library was completed, the head librarian wanted to bring all books from all departments into the large new building. Our position was not readily understood, but the authorities were finally persuaded to make an exception in our case and allow us to retain our own separate library.

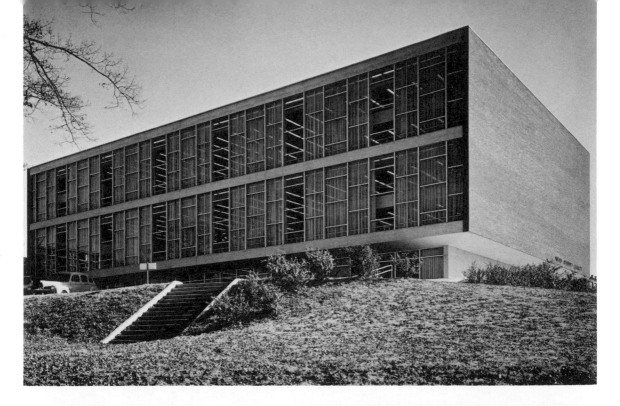

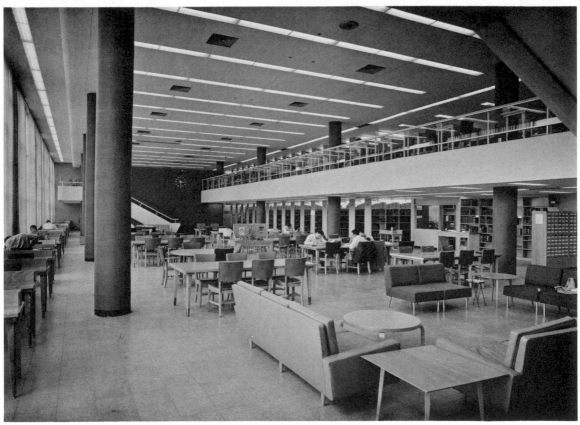

North facade and general reading room of the Georgia Tech Library, designed by Bush-Brown, Gailey, & Heffernan. Photographs by Joseph W. Molitor.

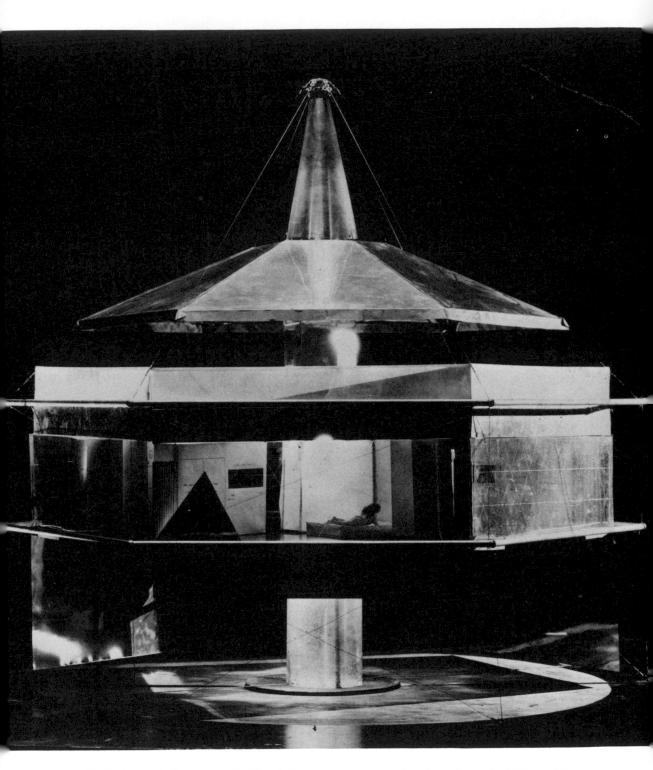

Buckminster Fuller was a childhood playmate at my grandmother's home in Milton, Massachusetts, where together we built a tree house. Bucky has been building tree houses ever since. His Dymaxion House is, I think, the most original of all his house concepts.

Of course, there were classrooms and offices for the faculty, and there was even what might be called a club room or meeting room for the students. Most important of all were the drafting rooms where each student had his own drafting table, and that meant several floors of large, well-lighted areas.

One unique feature of the building was an open space without enclosing side walls. It was under the library and overlooked a landscaped piece of ground that was partially enclosed by the projecting wings of the building. Both areas — inside and out — could serve as places for freehand drawing, as well as for an occasional social gathering in warm weather.

Some of the exhibitions and lectures in our new building were of such general interest that they drew people from outside the school. The exhibition of the "Family of Man," sponsored by the Museum of Modern Art in New York, was one such, and a lecture by Buckminster (better known as "Bucky") Fuller was another. Bucky had been a playmate of mine at an early age, as he lived in a house on a lot adjoining my grandparents' house in Milton, Massachusetts, and we had built a tree house together. He has been building tree houses ever since. The most original, a house raised above the ground, held up by wires from a central pole, he entitled the "Dymaxion House." His international fame, however, rests upon his creation of the "Geodesic Dome," consisting of a labyrinth of metal triangles that can be combined to enclose a space of almost unlimited dimensions.

Bucky has a great gift as an inspiring and untiring speaker. When he came to Georgia Tech, he had a time limit because of a commitment in Canada where he was also due to appear. I found it impossible to bring his speech to a close, and while I finally succeeded in getting him off the platform, he was still talking to the audience as he walked up the aisle and out the door on his way to the waiting taxi.

Of the many exhibitions, one of the most interesting to me was entitled "A Half Century of Architectural Education." It was put on by the faculty and students at the time of my retirement and consisted of selected student work exhumed from the past. In renewing my acquaintance with some of these early drawings, I was impressed by the high quality of the renderings from the freshman year on as well as the painstaking and skillful graded washes using Chinese ink, as derived from the teachings of the Beaux Arts, but long since abandoned for more efficient and less time-consuming presentation methods.

There were speeches and there were gifts, and it was all very emotional, with mixed feelings of the kind I am sure everyone goes through when the day of retirement finally arrives.

Photograph on page 56: The classical library in Duxbury, Massachusetts, designed in 1908 by Joseph Everett Chandler, gained a sensitively detailed modern addition, designed in 1965–1967 by the architectural firm of Morehouse & Chesley.

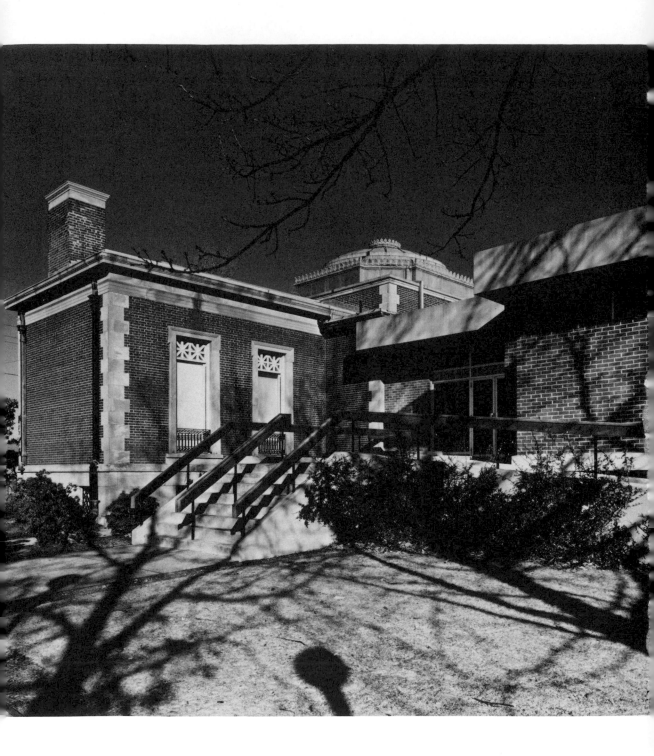

4. An Example of Change: A Modern Addition to a Traditional Library

The usual difficulty experienced by most people when they retire—giving up a busy professional life and trying to adjust to a life of leisure—was eased for me by a partial continuation of my role in architectural education. I organized two-week summer seminars for teachers of architecture under the joint auspices of the Association of the Collegiate Schools of Architecture (ACSA) and the American Institute of Architects (AIA). It was not until 1965, after giving up the chairmanship of this project, that my attention turned to the affairs of our newly adopted home town of Duxbury, Massachusetts.

The house that we moved into on St. George Street was hardly more than a stone's throw from the Duxbury Library. It had been Mrs. Bush-Brown's family summer residence ever since 1911, two years after the original library was completed. That there had always been an intimate association with the library is borne out by the fact that Mrs. Bush-Brown's father, James S. Conant—a well-known Boston wood engraver and halftoner, a skillful artist—created the bookplate used by the library in all the books.

The 1908 library has an exterior of brick and stone, the windows are of single-pane French plate glass, and the roof is of copper. No expense was spared to make this building handsome and permanent—an edifice the citizens of Duxbury could look upon with pride.

I am not sure that everyone did look upon it with pride, because it was the only masonry building in a town where all the buildings were made of wood, including the churches. Except for foundations and chimneys, and one or two brick end walls, the houses were, and in most cases still are, of wood. But because it held to the design principles of classicism, it did maintain the colonial tradition of the town's architecture. And in fact, the Duxbury Library is an excellent example of early 20th-century architecture.

As one of my major interests is the history of architecture, it was only natural, when I became involved in the rebuilding of the library, that I should wish to find out the name of the architect of the original building. It seems that the library project began as a private venture and was not owned by the town. Hence there were no records in the town office, and there seemed to be no available information on the name of the architect, the builder, the others who participated, or the cost of the building. The only person I knew who had any ideas on the subject was Mrs. John Figmic, the Duxbury head librarian, who came from Plymouth and who felt sure that the architect was Joseph Chandler, who had also come from Plymouth. But there was no proof.

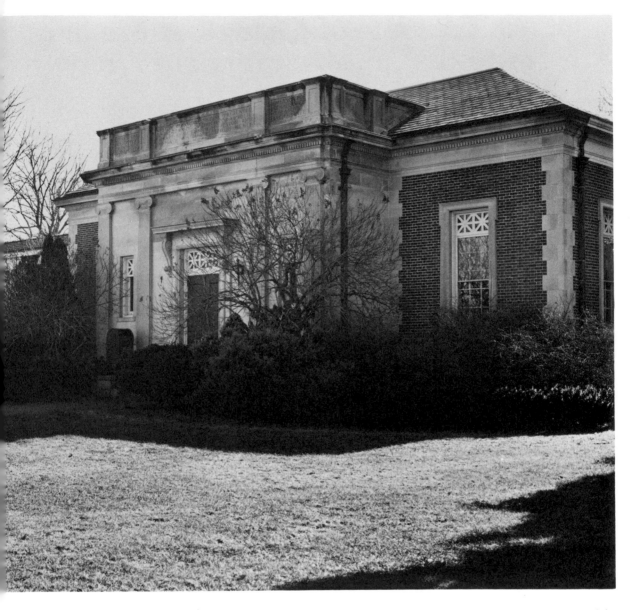

Research was needed to determine the architect of the original Duxbury Library (right). A visit to the library in the nearby Cape Cod town of Sandwich (above), whose architect was definitely identified as Chandler, convinced me that Chandler had designed both buildings. Photographs by James Brett show closely related detailing of the two buildings.

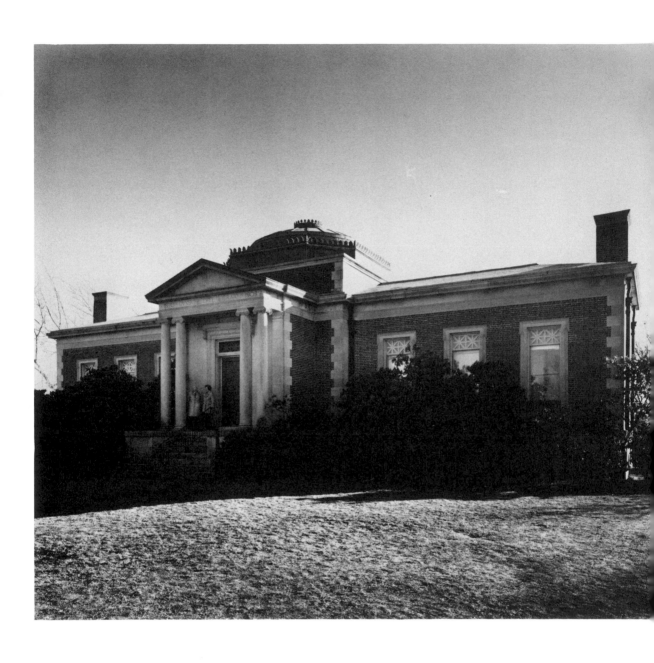

Later, when I was on a tour visiting town libraries, I was particularly intrigued by the library in the nearby Cape Cod town of Sandwich because the materials used and the motives and details of the exterior were identical with those of our Duxbury Library. On inquiring about the architect, I came up against the usual response—complete lack of knowledge. But the librarian took it upon herself to contact town officials, who looked up the records. They found that their library was built about the same time as the Duxbury Library and that payments for architectural service had been made out to Joseph Everett Chandler, Architect, of Boston. That clinched it as far as I was concerned.

To comprehend the form and features of the original building designed and built (1907–1909) to serve as a library calls for a look at the period preceding it. Richardson Romanesque was the last of the so-called revivals, as exemplified by the Cambridge and Quincy libraries and Trinity Church in Boston's Copley Square. It was brought to an abrupt end with the death of H. H. Richardson in 1886 and the impact of the 1893 Chicago World's Fair where the classical tradition reasserted itself, exerting a tremendous influence throughout the country. The Boston Public Library by McKim, Mead, & White, also in Copley Square, is a notable example of this revival and return to classicism.

With few exceptions, town libraries conformed to classical principles—to the earlier tradition of colonial and federalist days or to the Greek revival that followed. As for the floor plan, it was in most cases basically the same — a central entrance leading into a central hall, with equal wings right and left, and something at the rear on axis, maintaining symmetry throughout. In Duxbury, the rear area took the form of an oval room with three tall windows following the curve of the wall, as did the door, the oval table in the center, and the wall shelving. It was a difficult and expensive design to carry out, requiring skillful craftsmanship. The central hall or rotunda was a square, with chamfered corners supporting a dome with an eye at the top, the one source of daylight, similar to the Pantheon in Rome. In fact, the whole conception is an attempt at monumentality in miniature.

The approach to the building from the outside is by a flight of stone steps leading up to a portico that is flanked by coupled Ionic columns supporting a pediment, the central compostion serving as an enframement for the central doorway. All this, as well as the window trim and the cornice at the top of the wall, is the end result of the work of Chandler, a man well versed in classical design as documented and taught in L'École des Beaux Arts in Paris and in the few schools of architecture that then existed in the United States.

Chandler's thorough grasp of classical form is obvious. It seems to me that there is evidence of the influence of the houses of Pennsylvania, Maryland, and Virginia with which he was familiar. Unlike the houses in Duxbury, many of the stately mansions to the south of us were of brick and the orders were

sometimes of stone. That gave them a more solid and substantial character, while wood houses tend to become more attenuated and delicate in form and detail. That is one of the factors that differentiates the library, setting it apart from its surroundings.

But this difference should not be overemphasized. The language of classicism is essentially the same, no matter where one finds it and no matter what the materials employed. It is all a revival of a revival—a return to our inherited tradition.

The view of the library as seen by the passerby was to remain unchanged for sixty years. Anyone in the library looking out would have seen continual change—the horse-drawn transportation of its early years giving way to the automobile in constantly increasing numbers. There was also change in the interior. The first librarian was followed by a man of literary and artistic taste, Fisher Ames, who was active in acquiring books. An increase in population brought an increase in demand for reading matter, which meant more shelves to accommodate an ever-increasing collection. In 1953 the first trained librarian took charge, ably assisted by others. As the inside became filled with shelves and the reading space was reduced, it became clear that something had to be done.

My active involvement came about with my appointment to the Study and Advisory Committee, set up to make recommendations on the future of the library. At the first committee meeting, the chairman, Edward Peters, an engineer who recognized the value of thorough investigation before making decisions, suggested that we consult the authors of a 1963 report on the Duxbury Library by the Division of Library Extension. It happened that Peters and I were the only committee members who had retired from active practice, in view of which and because of our professional experience, it was only natural that we should be the ones to contact this agency in Boston. The valuable information furnished us included a list of recently constructed town libraries in eastern Massachusetts. This initiated our search for what was happening in other towns near Boston and along the South Shore.

We discovered that almost all the original library buildings dated from the first two decades of the 20th century; the majority were of classical design; and where expansion had taken place, it was by means of an addition rather than a replacement. Thus the situation was similar to our own, and in judging how they handled their problems, we could learn a great deal that would guide us in what to do and what not to do.

While making this survey, we were thinking about our own project: What specifically was the program we should present to the architect we would appoint? I knew any architect would be grateful for definite information about what was desired. Hence we wanted to have an agreed-upon set of basic requirements from which there would be no major deviations.

The plot plan on the opposite page shows that the original building faced north on St. George Street. Close by to the east, a wide roadway gave access to the schools, blocking off any extension in that direction. A parking lot was essential and this could be to the west. Therefore, if we were to preserve and utilize the existing library — and there was every reason for doing so — the addition would have to be attached to the rear, extending in a southerly direction.

My conceptual sketch of the layout showed a flight of steps from the parking lot leading up to a new main entrance in the proposed addition. That would open into the central room of the new library and directly ahead would be the main circulation desk in front of what had been the rear curved wall of the back room of the existing library. The original windows, now open doorways, would provide access between the new and old building. Book stacks would be in the center of the addition, surrounded by reading and working space on three sides and by the children's wing at the rear on ground level.

This was an obvious overall solution that, once conceived, was never challenged. Thus we were ready to deal with a matter of the utmost importance—the selection of an architect. After a good deal of investigation, the final choice was the firm of Morehouse & Chesley of Lexington, a partnership of two young Harvard graduates, Richard Morehouse and John Chesley. For a time after graduation they had been with The Architects Collaborative. Since forming a firm of their own, they had designed a number of libraries. As it happened, Chesley lived in Scituate, near enough to Duxbury to assure adequate supervision when the time came.

It was a novel experience for me to find myself acting the part of the owner in dealing with architects. Fortunately, we agreed on most issues, and they accepted the conceptual layout without hesitation as the basis for further study and more precise definition.

Once we settled the question of the basic plan and the architect, the character of the architecture was the next consideration. There was never any doubt in our minds that the new library would take advantage of recent technological improvements and social demands—that is, the building should be modern in design. In many instances the acceptance of modern as today's style — if one can call it a style — has resulted in a lack of harmony between the new and the old when the two are joined. I believe that this should be avoided if at all possible. That the architects shared this premise is revealed by a statement from their application for federal funds: "The overall intent will be to restore the existing building to its former beauty and be useful in an uncluttered way. The addition will be modern and efficient and the objective will be to have it blend comfortably with the original building. This will be done mainly by scale and the use of similiar materials."

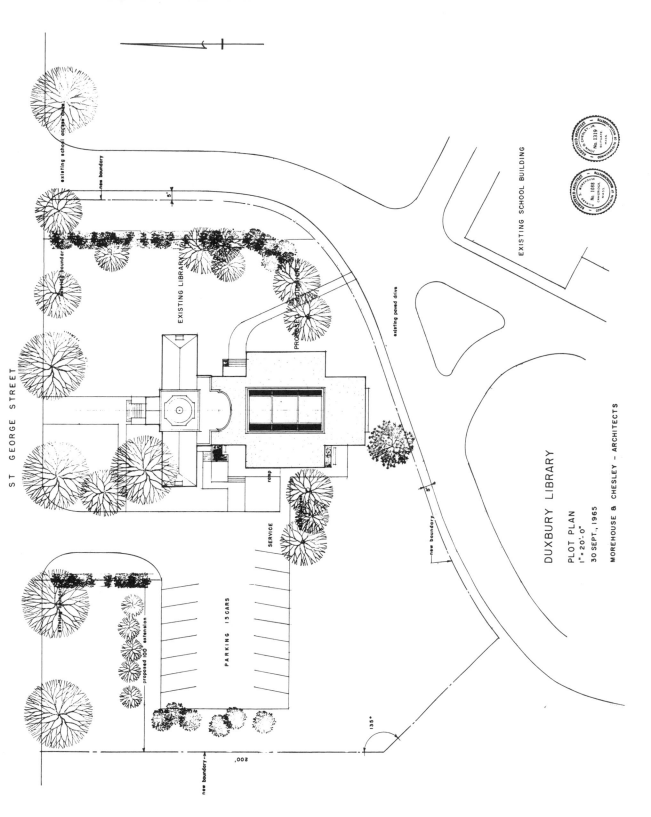

Plot plan for the Duxbury Library shows the original building facing north on St. George Street and the new wing extending behind it with major entries from west and east.

The modern approach to design is indicated by some of the building's special features that were included in the evolving plans.

When Peters and I visited the Putterham Branch Library in Brookline, designed by The Architects Collaborative, I was impressed with alcoves projecting out from the exterior wall, thus creating space for well-lighted shelving. This is making use of what is called the cantilever, and in this case it means extending the floor out beyond the exterior wall of the building. This feature was made possible in masonry construction by the use of reinforced concrete, a product of the 20th century, and it has been effectively used in many modern buildings. In the Duxbury Library it was adopted along the east and west walls of the addition.

Another idea proposed by our architect was raising up the center portion of the interior space of the addition, similar in concept to the nave and aisle treatment of the medieval Gothic church, but here it would be a 20th-century flat, monitor-type roof rather than a vaulted ceiling. That would enable us to have a north skylight at one end, thus lighting up the area in front of the circulation desk. It also made possible a second tier of stacks over the central stack area.

Creating space and utilizing that space to advantage are, of course, among the architect's prime objectives. How the central rotunda and west wing came to be used as an art gallery is an example.

The rotunda area seemed to be well suited for exhibitions of various kinds, and the west wing had been designated for special services. As the addition neared completion, everything movable was cleared out of the interior. Upon viewing the barren spaces, my wife, Marjorie C. Bush-Brown — one of the original members of the Duxbury Art Association, which no longer had a place to exhibit works of art because the building they had used burned down—had a vision of what could be done. Why not use both the rotunda and the west wing, in combination, to create a gallery in which to display painting and sculpture?

The plans for this extra and unanticipated piece of work called for covering the windows in the west wing with a continuous wall surface and installing

The new circulation desk continues the circular theme of the original building. A north skylight lights up the area in front of the desk. Photograph by James Brett.

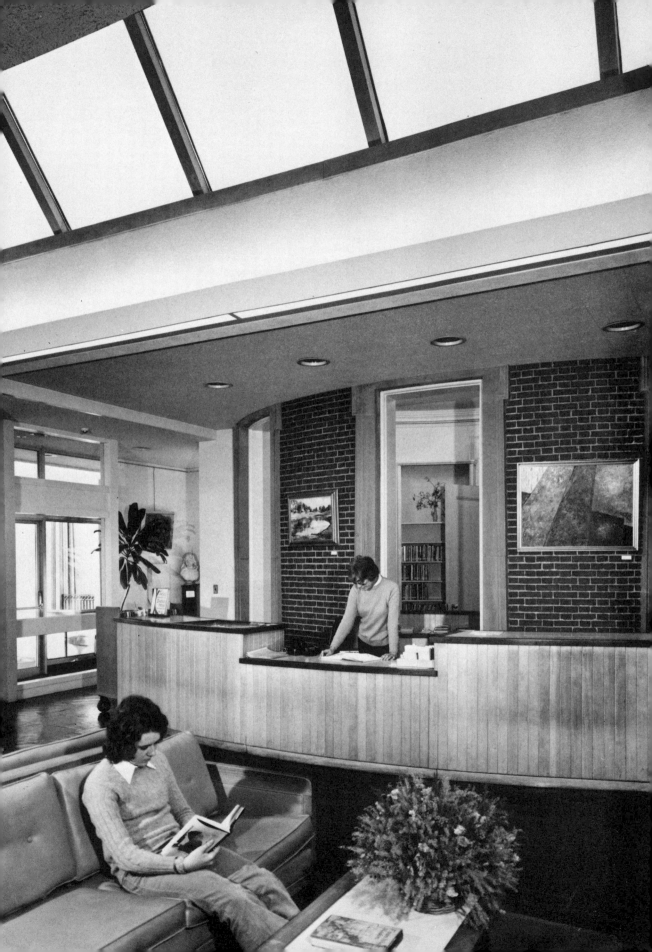

The original building, with its classical details restored, became a reading room and exhibition area for local art shows. This imaginative concept was the inspiration of my wife, Marjorie.

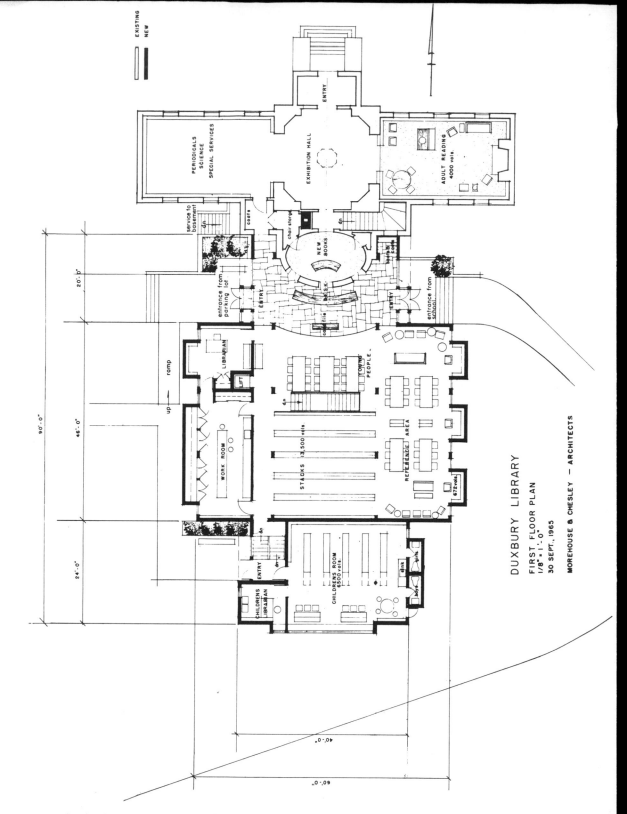

DUXBURY LIBRARY
FIRST FLOOR PLAN
1/8" = 1'-0"
30 SEPT., 1965
MOREHOUSE & CHESLEY — ARCHITECTS

The final plan for the main floor of the new Duxbury Library shows four principal zones: the central rotunda flanked by balancing wings, the transitional oval room and circulation desk, the stack and reading areas, and the children's wing.

special lighting similar to that used by the Cambridge Art Association (of which my wife was an exhibiting member) in their remodeled quarters on Garden Street. Fortunately for us, we had better proportioned and more ample space for this project both in width and in height.

By the summer of 1968, when everything and everyone had been moved out, the committee could give final directions on a revised layout, as illustrated on the opposite page. The space is divided into three principal parts: the central rotunda, flanked by wings that balance each other to the east and the west with no through-wall separations, thus constituting a single uninterrupted area. The east wing was to serve as an adult reading room.

The work in all three areas was due to be completed before the end of November, so December 1 seemed to be an appropriate date on which to christen the gallery. The event took the form of an opening of an exhibition of the best examples of the works of local artists. As people entered the new extension to the library and passed through the oval room into the central rotunda, they were greeted by an unfamiliar sight: in front, above, and to the right and left, was an unobstructed, high, well-lighted open space with new floors, restored and repainted walls and ceilings, with the work of Duxbury artists on display.

There was one fortuitous incident connected with this afternoon at the library that I cannot help recounting. In response to our invitation, Hugh Stubbins had driven from Cambridge to be with us for the occasion. While taking a tour of the building, we were joined by Jack Chesley, and in the course of conversation, it came out that Stubbins had been Jack's teacher at Harvard. Since Stubbins had been a pupil of mine and Jack had been a pupil of Stubbins, all three of us were involved, directly or indirectly, in the design and creation of the building we were here to appraise and to which we were to drink its health in the hope that it would serve its purpose well.

Because it was the architects who had to bear most of the brunt of the long, drawn-out operations, I was glad to hear Jack Chesley say, "Of all the buildings of this general type we have designed, the Duxbury Library is my favorite."

(For a more detailed discussion of the addition to the Duxbury Library, see the Appendix.)

Photograph on page 70: The Francis A. Countway Library of Medicine in Boston is not an addition to an existing building, but its architects, Hugh Stubbins and Associates, faced on a different scale some of the same problems posed by the Duxbury Library. Since the building relates to a classical complex, its massing, materials, and cornice details have been handled with respect for its neighbors and antecedents. Photograph by Louis Reens.

70

5. The Architect's Job As the Architect Sees It

To understand the architect's approach in serving as a contemporary designer, let us examine more fully the character of the new library building. There is nothing unusual in attaching an addition designed in 1965–1967 to a building designed 60 years earlier in 1907. It is quite typical of what has been happening to libraries in the majority of New England towns. Observation of the building will show the differences between the new and the old, and may help towards an understanding of what was done and why.

There is the matter of surface treatment; there is the problem of structure and the part it plays in determining form and space; and finally, there is the consideration of function that takes advantage of modern technology to achieve efficient operations.

Consider first the negative aspect of modern design—absence of ornament. In the Duxbury Library there is a clear distinction between the new and the old building. As you approach from the parking lot towards the steps and new main entrance, you see the horizontal crowning feature of the wall, a wide band of projecting concrete, absolutely plain and flat — no moldings or ornamentation from top to bottom. Looking to the left at the west wing of Wright Hall (which is the name of the original building), you will see the stone entablature at the top of the wall, crowned by a delicate, projecting cornice, its supporting moldings in curved profile and the flat surfaces below divided into several unequal horizontal strips, all in accord with classical formulae.

Why shouldn't this motive have been carried out in the addition? For one very simple reason: the material used in the new building is poured concrete finished to resemble the original limestone. But would it not have been possible to buy limestone and have it carved to conform to the original design? Yes! But it would have been expensive, and there might have been roofing problems. The modern building has flat roofs as a practical solution, and classical cornices as a crowing feature are no longer practical. Besides, because of the lack of demand for carved limestone such craftsmanship is almost nonexistent today. We are in a new era and our ideas of design have changed: the language of classicism is spoken no longer, except as it is attempted, usually unsuccessfully, in speculatively built wooden houses in the suburbs or occasionally in restorations of historic buildings. Restoration has its place in our society when conceived in the spirit of Williamsburg, Virginia, or similar projects such as those sponsored by the Society for the Preservation of New

England Antiquities — excellent examples of the past, but hardly legitimate objects for reincarnation in our time.

Visual design is made up of many elements. If ornament is eliminated, the architect's palette still contains color and texture in the surfaces confronting us.

The variegated red brick in Wright Hall contrasts pleasantly with the limestone trim and quoins and with the green copper roof. The only discordant note at certain times of year is the purple rhododendrons on the St. George Street front of the building — lovely by themselves but producing a strident note next to the red brick behind them.

On the inside, as you enter the new building from the parking lot, you face the main desk that is in front of and follows the curve of what was the exterior brick wall of the original building behind it. To have an exposed brick wall inside a building is unconventional, and it bothered some people who wanted the bricks covered up. The architects felt that besides bearing witness to the line that divides the new and the old parts of the library, the brick wall made an agreeable background of variegated color, contrasting pleasantly with the rest of the interior. So, in spite of protests, the brickwork has been left exposed in its original state.

To illustrate the more fundamental difference between the new and the old—the use of new materials and the adoption of a new structural system—I will recount an episode in my past that may help to explain what is new and why modern has succeeded in supplanting historic styles. In the later years of my Atlanta experience, I was asked to appear before a joint meeting of the southeast states architectural licensing boards held in Savannah, Georgia. I was questioned about why Georgia Tech and other schools were no longer teaching "basic principles" as exemplified by the accepted standards of the past. I pointed out that all architecture down to the 20th century was dependent on masonry—that is, brick and stone, and generally speaking, it is stone that has served as the bones of important buildings. But today we have a new structural material — steel — and that changes everything if we are to take advantage of its potentialities. The so-called basic principles of classical architecture no longer apply.

In addition to the steel frame type of structure soaring to the sky in our cities, there is also reinforced concrete, used in buildings of several stories that seem to be going up wherever one looks. (Incidentally, it is reinforced concrete that is used as the framework of the new Duxbury Library.) Here again it is steel rods embedded in concrete that give it strength, and these materials in combination provide the skeleton of a building.

It is not my intent to try to explain the technicalities of new materials and new structural systems. I would only observe that columns or piers can now be spaced far apart, supporting beams or trusses of long span, and this can result in larger, more spacious interiors. Another factor is the use of glass in enlarged single panes that does away with the closed-in effect of traditional interiors.

There can be the feeling in modern buildings that the outside and the inside are related and that the outside and the greater amount of daylight are there to be enjoyed from the interior.

It is often said that people are not interested in looking out. But with the enlargement of windows, the outside does have a way of intruding, and there is no doubt that surroundings are of special concern to the contemporary designer. How does the landscape appear from within, and conversely, how can landscaping be made to relate to the building from without? Insofar as it is attainable, a satisfactory interrelationship should be a major objective.

One great advantage we of the 20th century have over our predecessors is the use of artificial lighting. The vertical window slits at the rear of the New York Public Library facing Bryant Park are spaced so that each window lights up the area between the book stacks. That was a good concept for its time and relatively effective in bright weather, but less satisfactory the further one is away from the window. Now books can be evenly and well lighted at any time of day or night independent of natural light, and stacks can be located in a central position (as they are in Duxbury) away from exterior walls, which is often a good arrangement. In the lower level of Duxbury's new building, there are no windows, and of course, no windows are necessary because of artificial lighting.

Still, present-day artificial light, which electrical engineering has made available for illuminating our interiors, is limited in scope. Daylight still has its uses, and although it is possible to do without it, natural light will always ·be welcomed by anyone who possesses sensitivity to the visual world.

A s for physical surroundings, a factor that does not always receive sufficient attention is orientation. The original Wright Hall faces north on St. George Street. That means that the addition extends in a southerly direction, and at the rear, the children's wing and the Duxbury Room over it could be provided with an unbroken expanse of windows facing south. In the central part of the addition it was feasible to construct a skylight facing north. Thus, by good fortune, it was possible in both cases to arrive at a satisfactory solution with respect to the points of the compass.

While the Duxbury Library expansion is small in size compared with expansions of large institutional or city complexes, the problems are the same. When a building is no longer able to meet increasing demands upon its service and an addition becomes necessary, there is one vital question that must be asked: How should what is about to be built relate to what has gone before from a design standpoint? There are those who say that today's idiom, as an expression of meeting today's problems, is so totally at variance with the past that there is no use trying to make concessions towards harmony between the two. One does not have to look very far to see examples of this kind of reasoning.

That was not the point of view subscribed to by those of us responsible for

the new Duxbury Library. While recognizing the validity of adopting modern design, we strove for a degree of unity and harmony between the new and the old insofar as this could be achieved by using similar materials and adhering to scale.

Scale has to do with the size of objects in relation to each other. For example, a doghouse that is the right size for a St. Bernard is out of scale for a dachshund, and similarly a doorway 6 feet wide by 14 feet high in a room where all other doors are the usual 3 by 7 feet would seem to be very much out of scale.

One of the advantages gained by dropping the floor of the children's wing a half-story to ground level was that it freed us from having to maintain the high ceilings of the rest of the building. It made it possible to lower the ceiling to a scale suitable for small children — on the theory that children would unconsciously react to their surroundings and feel more secure and at home in a less imposing setting.

With a growing emphasis on practical solutions in planning, today's architect thinks that providing an efficient working plant is at least equal in importance to creating a work of art. Let us review those factors that the architect must consider in the design process. First, he deals in surface treatment in which color and texture as well as detail play a part. Second, he makes use of materials for structural purposes, for holding up and enclosing, from which form and space are derived. Finally, he combines and arranges these elements so that the occupants can operate effectively in whatever they do—in other words, function.

The work of the architect as designer is carried out through drawings, writings, and occasionally models, all of which in practice begins only after the intent of the owner and all contributing and limiting conditions are known. Thus we come to the first and perhaps the most important step in planning procedure—the program.

A good example of successful programming on a large scale is that of the Francis A. Countway Library of Medicine built under the auspices of Harvard University in Boston. To quote from the handbook describing the project: "When the architects were selected (after an extensive canvass of the leading architectural firms in the United States) they were presented with an explicit

One of the advantages of 20th-century technology in library design is the use and relative sophistication of artificial lighting. But in 1898–1911 when Carrere & Hastings designed the New York Public Library, narrow slit windows had to be used to bring natural light to the areas between the bookstacks. Photograph by Martin Munter.

and detailed building program which delineated the concepts and asked that they be incorporated in the design." The architects so selected were Hugh Stubbins and Associates of Cambridge, Massachusetts (a name which seems to have a way of recurring at intervals throughout this narrative). Architects are rarely so fortunate as to be given a well-articulated program before beginning work on the problem that confronts them. If it were possible to list all essential requirements from which there would be no changes or deviations, the architect's job as designer would be relatively easy. What usually happens is that the architect has to dig out the information, with a final set of requirements arrived at only after a period of trial and error in an extended search for what is wanted, what is needed, and what is possible within the range of existing conditions and available funds.

It would be a mistake to think of an architectural design problem as similar to a crossword puzzle in which there is one and only one answer. No two architects presented with the same program, no matter how comprehensive and precise, will come up with the same solution in all particulars. But there is no doubt that with a well-thought-out program there is a better chance for a satisfactory result.

In the case of the Duxbury project, there was an unusual amount of investigation of the problem even before the architects were selected. This continued during the programming and early study stages. Although there was no formal program listing all specific requirements, there was a meeting of minds on the basic conceptual scheme, and once the architects' preliminary drawings were adopted, there was no great trouble detailing and finalizing the design.

To bring a design to a successful conclusion, however, the architect needs help. Even during the preliminary sketch stages, engineers are called in as consultants in the design process. This is a customary procedure. Only a few of the larger architectural firms have engineering specialists within their own organizations.

On the Duxbury job, the architects engaged a civil engineer on structure, and then a plumbing and heating engineer and an electrical engineer, all of whom, as the design crystallized, furnished drawings and specifications describing their par in the addition as it would eventually be built.

That this is normal procedure is recognition of the fact that while the architect must know something about all aspects of what science and technology have to contribute, he is not, as a rule, a specialist in any one branch.

In this age of specialization the architect remains a generalist. The overall concept is his, and his job is to pull everything together. The architect thus becomes the coordinator — the captain of the team — and he is responsible, insofar as any one man or firm can be responsible, for the end result.

We have now had a look at what the architect does in the practice of his

profession. But there is more to the present-day architect's position in the building industry. This calls for a brief survey of recent developments that show the architect's relations with others, professionals and nonprofessionals alike.

6. The Architect in Relation to Others

The revolution in architectural design was the result of the architect's realization, often reluctantly arrived at, that historic styles were no longer relevant when applying new technology to society's changing and expanding needs.

The architect—in practicing his profession, even in a small building such as the Duxbury Library—deals with and is dependent upon the help of many specialists in the design and in the execution of that design.

Looking back over the years, I am struck by the number and variety of new fields of specialization in science and engineering and even new professions that have arisen within the construction industry during my lifetime. Changes in organization and procedures have been as far-reaching in their impact as was the revolution in design, but these changes have come about gradually and naturally, and with less violence, and therefore may be regarded as evolutionary rather than revolutionary.

Architecture is an old profession, possibly the oldest, which goes back to ancient Greece and the name of Ictinus, the architect of the Parthenon, and to the Roman Empire and the writings of Vitruvius.

In this country it was a group of architects in New York who formedan association in the year 1857. Boston, Philadelphia, Chicago, and other big cities followed suit, resulting in the creation of a national organization called the American Institute of Architects (AIA). Now there are chapters in every state.

In considering this civilizing process—if one can call it that—let us first take a look at the individual architect's relationship with his fellow architects.

When I went to Atlanta in 1922, there were those who could remember when architects would pass one another on the street without speaking! That was evidence of the pioneer spirit of ruthless competition left over from the time when Atlanta was settled not long before the outbreak of the Civil War.

Its accidental birth was brought about by two railroads. The story has it that a railroad from Charleston, South Carolina, was being built to join a railroad coming down from Chattanooga, Tennessee, which were intended to meet at Decatur, Georgia. But the people of Decatur said that they were not going to have a dirty terminal station in their town—it would have to go on. The spot where the two railroads met was an open field, now the center of Atlanta.

With the formation of a chapter of the AIA in Atlanta in 1906, there followed a remarkable transformation. Architects sat down at the same table and came to know each other. They were called upon to subscribe to a code of ethics and professional standards that, when followed, proved to be mutually

advantageous and served as guidelines of conduct for those in the profession as well as for those outside.

Not everything is peaceful and friendly in the competition for jobs. That would be too much to expect. But by and large the architectural profession has become unified and disciplined, able to take care of its own interests and better able to render satisfactory service because of its ability to restrain internal conflict.

Outside the architectural profession, the ever-expanding construction industry has brought about new and changing relationships between the architect and other individuals and groups, including newcomers struggling for recognition. This has required a period of adjustment needed to arrive at satisfactory long-range working arrangements.

The first storm cloud on the horizon that forecast a possible challenge to the preeminence of architecture as the first, the only, and the all-enveloping profession in planning and designing came from the engineers.

It was the machine that ushered in the industrial revolution of the 19th century. And as the products of the machine, with all that entailed, began to proliferate, the need for specially trained technicians became obvious, leading to the establishment of land-grant colleges of agriculture and engineering throughout the nation.

It was not the machine itself that bothered the architect. Such subdivisions of engineering as plumbing, heating, ventilation, and lighting and such mechanical marvels as the elevator, which made the skyscraper possible, were all subservient to overall planning.

It was the civil engineer, with his knowledge of how new structural materials could be used, whom the architect feared. I well remember one Boston architect who was very outspoken about engineers. He came to Atlanta on a speaking tour under the auspices of the AIA and was introduced by the president of Georgia Tech to the audience, most of whom were engineering students. In his remarks he said in effect that the only thing engineers knew was what came out of a slide rule—not exactly the kind of statement to promote good feeling. It was indicative of the kind of antagonism that then existed, due, perhaps in part, to a fear that the practice of architecture might be taken over by the engineers.

In the days of my apprenticeship, I recall hearing more than once from practitioners remarks like this: " 'We' (meaning 'we architects') design the building the way we wish to have it and then call in the engineer to make it stand up." No suggestion here of the possibility that the engineer might have something to contribute to the overall design. That there could be collaboration was a concept that could only come with a new approach to design on the part of the architect.

In Duxbury in 1965, about fifty years after the conversations just de-

scribed, when the study committee was asked to recommend what should be done to expand the library, it was the engineer and the architect on the committee who took the lead and worked together in investigating and formulating a program. Soon after their selection, the architects called in structural, heating, and electrical engineers to consult with them. This example of what is now usual procedure illustrates the change in attitude that has come about between the two professions. There is too much to be done by both professions and too much in the way of common interest to allow for the perpetuation of rivalry.

After engineering, with its many subdivisions, the next profession to appear on the scene was landscape architecture. Not long before I was a student at Harvard, a full-fledged course in landscape architecture had been introduced—something new in the academic world. The landscape men were in a separate room, and there was little contact between them and the students in architecture. As I remember, the architectural students looked down on landscape architecture as having questionable legitimacy. The attitude is summed up in the words of an architect who felt that there was no reason for such a hybrid profession: "A good architect and a good gardener can do it all." But one had only to look at what had been done and what was being done by such landscape architects as Fredrick Law Olmstead in New York's Central Park and in Boston's Fenway to recognize that a profession of the highest standard had already emerged. Whatever may have been the pros and cons, Harvard had recognized the need for thorough training for this new profession, and it was not long before other universities followed its lead.

Landscape architecture is now a well-recognized profession with its own educational programs and association of practitioners. Following the example of the AIA, it established its own code of ethics and procedures, and with the publication of a periodical, its identity has been further defined.

Architecture and landscape architecture have this in common: they are both dedicated to the idea that the visual aspect of our surroundings is of importance and affects our lives for better or worse. There is no longer any open conflict—if there ever was any—and both professions have much to offer in working together on such projects as large-scale housing and city planning as well as broader problems of regionalism.

By the time landscape architecture and the various branches of engineering had come of age, other groups were beginning to organize, seeking recognition as independent design professionals. They included industrial designers and those who wished to be called interior designers rather than

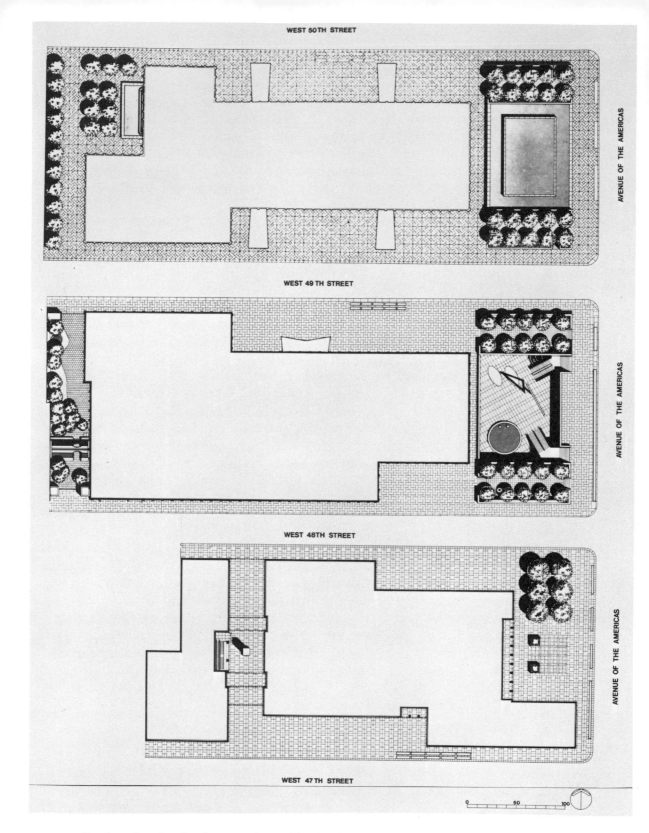

WEST 50TH STREET

WEST 49TH STREET

WEST 48TH STREET

WEST 47TH STREET

AVENUE OF THE AMERICAS

AVENUE OF THE AMERICAS

AVENUE OF THE AMERICAS

0 50 100

Landscaping plan for the extension to New York's Rockefeller Center shows malls, plazas, pools, sculpture, trees, and fountains. Courtesy Harrison & Abramovitz.

interior decorators. The most recent specialists to surface were the people who perceived the overriding need to do something about our cities. Their field is city planning, and the architect's involvement with it deserves special attention.

As mentioned in Chapter 3, the School of Architecture at Georgia Tech was the recipient in the 1950s of a fund for expansion that included the inauguration of a graduate course in city planning. An advisory committee, with Professor Adams, the head of the city planning course at MIT, as its chairman, was invited to Atlanta for consultation.

As director of the course in architecture, I was aware of the unyielding position of those in practice who thought of city planning as the exclusive province of the architect, as it had always been in the past. I soon found that there were others who claimed the right of proprietorship. The members of our visiting committee believed that a course in city planning could be conducted under the auspices of any one of several different departments. Civil engineering was considered a proper mentor, or it could be associated with landscape architecture. What most surprised me was to find that the geographers at the University of Georgia in Athens—where a course in landscape architecture had already been established—thought of themselves as having the qualifications to conduct such a course. And later I learned that there were still others who claimed the right of supervision.

The consulting committee had no objection to having city planning handled as a part of or an adjunct to the course in architecture, especially since we were the first to request it. In universities or technical schools this is usually where it is found, probably because it is the educators in architecture who take the initiative in introducing such a course. As an architect, I believe this is where it should be.

From this brief account of the adoption of city planning for study in higher education, it will probably be no surprise that, considering the all-inclusive character of the subject, it could not long remain completely under and subservient to any other single discipline—even a discipline as broad in scope as architecture.

In this regard, what occurred at the University of California at Berkeley is significant. Under the deanship of William Wurster, the name of the school was changed in 1960 from "The School of Architecture" to "The College of Environmental Design," in spite of the protests of San Francisco architects. It included a degree-granting course in city planning in addition to the course in architecture. Earlier in 1935, Harvard had done much the same, naming the school "The Graduate School of Design," which includes four main divisions: (1) architecture, (2) landscape architecture, (3) city and regional planning, and (4) urban design, each with its separate degree.

In the many fields encompassing the design of cities and the planning of our environment, what is needed is not so much the demarcation of boundary lines between professions as a sense of cooperation, with leadership provided by whoever within the professions is capable of gaining the confidence of those concerned.

First, teamwork is the vital factor; second, it is necessary to select an inspiring leader to assure success.

Understandably, architects believe that the men best qualified to provide that leadership are those who have had at least some background in architecture. But that assumption cannot be taken for granted. It has to be earned.

You may be wondering what city planning has to do with a small public library in a town 12 miles from the nearest city of Plymouth and 37 miles from Boston. It is becoming increasingly evident that the city and the metropolis can no longer be isolated from their surroundings. Soon the whole region becomes part of the problem confronting the planner. Every building should be thought of as part of a larger whole. This is not an obvious conception, especially for a New England township that has always treasured its independence. But by force of circumstances, as time passes, the township becomes less and less self-sufficient. In addition to planning within its own borders, the town is affected by and dependent on what is being done in neighboring towns and in fact within the whole region.

It is the schools of higher education that have been providing nourishment for the new professions and helping to bring about cooperation and collaboration rather than division and rivalry. And this gives hope that our dying cities may be rehabilitated and our natural resources saved from destruction.

To complete this brief survey of the relationship of the architect with other professionals—some of whom are, or were, potential rivals, but more often than not have become willing co-workers in the adventure of creation — there remains one essential operator in the American construction system who must be considered. That is the building contractor.

Let us return to the Duxbury Library example once more. Upon approval of the architect's plans and signing the contract, the dual relationship between owner and architect gives way to a triple arrangement: owner, architect, contractor — the contractor to build the building and the architect, acting as a representative of the owner, to make sure that the plans are carried out. The question comes to mind: could not this arrangement be simplified by reducing it to a two-way proposition — the architect assuming all responsibility for the construction as well as the design?

From its formation in 1857, the American Institute of Architects has taken the position that the architect's work is primarily in design and supervision, not in the actual work of construction. This is based on the conviction that architecture is a profession in the sense that law and medicine are professions, operating on a fee basis for services rendered by well-educated, licensed practitioners and not on a merchandising basis.

In spite of some attempts to modify this hard and fast rule, the architectural profession has firmly maintained its original declaration, believing that their own as well as the interests of their clients and the public are best served

by denying members of the institute the right to become directly involved in the business of building.

The differentiation to be kept in mind is that the architect is a person of creative ability and is capable of describing exactly what is to be done; the builder is the one who carries it out. The one visualizes, the other makes the vision become a reality. In making this distinction there should be no implication of superiority or inferiority. Both activities are equally important.

The architect's insistence on his prerogatives is logical enough from his viewpoint because of his conviction that what he has to contribute as artist and planner is both essential and unique.

Whatever may be the difficulties due to differences in temperament, interests, and outlook, it is imperative that builders and architects recognize these differences and adjust to them in the interest of what both seek to accomplish.

For a number of years members of the American Institute of Architects have been meeting with representatives of the Associated General Contractors to discuss their mutual problems and continually update the various AIA documents that are the standards for the construction industry. Now this cooperative arrangement takes on new importance as changing concepts arise in the industry. I quote Bernard B. Rothschild as follows:

"The traditional roles of architect and contractor are being challenged by the appearance of the 'Construction Manager.' This new entity is conceived as entering the picture at the start of design, making detail decisions related to the Architect's work and continuing into the construction phase, making policy decisions with regard to construction contracts which the Owner will enter into as well as expediting and monitoring the process of building itself. One can only hope that this prospect of change will prove the stimulus needed to bring much-needed refinement to both architectural practice and general contracting and help to resolve many of the long-standing differences existing between these two important elements of the building industry."[1]

The profession—any profession—has to be constantly on the alert to make sure that the standards it has set for its membership are worthy standards and are adhered to. But it also must make sure that it is not imposed upon or undercut by others. This would appear to be a never-ending process in the workings of democracy.

Photograph on page 86: As we look back from the seventies to the beginning of the modern movement we are already looking at architectural history. The 1925 Bauhaus Building in Dessau by Walter Gropius was a milestone in the modern chapter. Courtesy The Architects Collaborative.

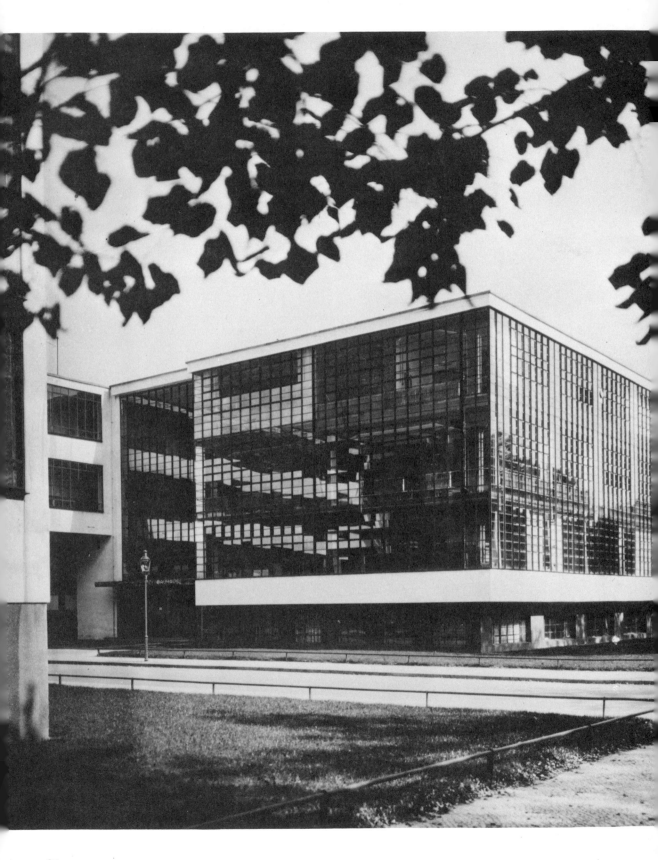

7. Modern Architecture in Perspective

The change that architecture has undergone in this century is symbolized by the difference in style between the original Duxbury Library in 1908, with its formal, classical design in the colonial and federalist tradition, and the modern design of the recent addition in 1968. The nature of this change — this revolution—will now be examined more fully in the hope that by viewing the architecture of yesterday and today in more general terms, this phenomenon we call "modern" can be better understood.

In the 1930s a new approach to the teaching of design was beginning to emerge. Students in the School of Architecture at the Georgia Institute of Technology were given greater freedom and were being encouraged to experiment in the use of new and unfamiliar forms that might bear no resemblance to historic styles. The manifestoes of the avant garde coming from Europe and the writings and creations of the few who were our own pioneers were among the influences at work in the continual search for solving contemporary problems in a changing world. In spite of criticism from outside, innovations were being introduced.

It was not, however, until 1945 that the school in Atlanta was to feel the full force of the revolution from within. Young teachers hired to handle the sudden increase in enrollment at war's end were, for the most part, ardent advocates of the new movement. Those from Harvard, directly influenced by Walter Gropius, were imbued with his belief that there must be a fundamental change in the practice of architecture towards the teachings of the Bauhaus. But the commitment to this kind of program was not limited to those coming from Harvard. As it turned out, the two most radical newcomers came from other schools.

It must be remembered that Mies van der Rohe, when forced by Hitler to close down the Bauhaus, had, like his predecessor Gropius, come to this country. His name became associated with other escapees from Germany who had established what became known as "the New Bauhaus." On his appointment as the head of the course at Armour Institute in Chicago (later to become the Illinois Institute of Technology), Mies was given a free hand in the teaching of architecture along lines very different from any instruction previously given in American schools, resulting in another powerful source of influence.

Perhaps radicalism is an inevitable accompaniment of revolution. Certainly some of the younger generation on our newly constituted teaching staff were not backward in expressing what seemed to older members to be an extreme point of view. The history of art and architecture was regarded with suspicion because students might draw inspiration from and make use of the styles of the past. There was even the thought that history might be abolished. The word "beauty" was dropped from the vocabulary. In its place the word "clean" seemed to depict what the radical designer strove to achieve. There was no doubt of the cleanliness in the drawings emerging from the drafting rooms. No ornament, of course, or obtrusions to mar the smooth, uncluttered walls. And what about books—all those large, handsome volumes illustrating standardized forms that had heretofore been regarded as basic in teaching and as source material in the design of buildings? It was reported that one teacher told his class that the books should be taken out of the library and burned.

It is true that many of these books were now seldom referred to. But the wish to destroy the records of the past, even if some of the remarks were not to be taken too seriously today, was disquieting. What provoked me as an historian and as a participant in recently executed traditional designs was the lack of discrimination on the part of the younger generation between the good and the bad. It seemed, as far as one could judge, nothing preceding the advent of modern was worth looking at. In other words, they did not bother to criticize the specimens of the past. They simply ignored them.

When the champions of immediate and total change were motivated by a spirit of idealism, as was apt to be the case, one could only hold one's fire in the realization that their assertions, insofar as they were irrational, were destined to be forgotten. Perhaps, in the meantime, it took some prodding by the extremists to spark the inevitable advance of the revolutionary front. Whatever the forces in combination that brought it about, it was quite evident that a growing number of recruits among prominent practitioners were joining the ranks of the modern movement.

A striking example is the case of Raymond Hood, the New York architect who with Howells had won the Chicago Tribune Tower competition as mentioned previously. This was a traditional design topped by a series of Gothic flying buttresses. It was not long thereafter that Hood became a leading

Rockefeller Center, begun in New York in 1929, was an important step in the transition between Beaux Arts and Bauhaus. One of its leading architects was Raymond Hood, who with J. M. Howells had won the Chicago Tribune Competition in 1922. As subsequently developed by Harrison, Fouilhoux & Abramovitz, the complex is still one of the most successful innovations in urban planning in the world. Courtesy Rockefeller Center and Harrison & Abramovitz.

figure in the group of architects engaged to design Rockefeller Center in New York. Hood had become a convert to change, and the project resulted in a successful modern design—exceptional in that all the buildings were planned to relate to one another as a unit with an open space in the center. It is a good example of attaining a sense of order in an otherwise chaotic cityscape.

Hood's conversion was soon to be followed by other progressive architects launching upon a new course, especially after the recovery from the war. But it was the schools of architecture that, I believe, deserve much of the credit for leading the way.

If there is one type of project that, more than any other, gives the designer an unusual opportunity to show what he can do, it is the exposition. Here the imagination is given free rein, unhampered by restrictions. Furthermore, from the viewpoint of history, world and national fairs are like weathervanes: they show which way the wind is blowing in the constantly changing visual world.

The first World's Fair in Chicago in 1893, with its assemblage of white classical buildings, both formal and monumental, ushered in the period of eclecticism. The next great fair in Chicago, The Century of Progress in 1933, "celebrated the demise of eclecticism by entirely ignoring it."[1] In between, there were seven national and regional fairs in different parts of the United States.

One of the fairs included an outstanding conglomerate of buildings by Paul Cret, the architect and teacher in charge of design at the University of Pennsylvania. The New York fair of 1940 is also worth mentioning if for no other reason than to call attention to a fascinating fountain by Jean Labatut, the head of architectural design at Princeton. Both of these men were Frenchmen with a Beaux Arts background. I cite their work as another example that leaders in education, regardless of prior training and experience, had become active participants in the common cause of revolutionary change in the decade before World War II.

There is another episode that shows the curious, uncertain, backward-forward flow of the revolutionary movement. A young man from Germany entered the school in Atlanta several years after World War II. Before the war he had been studying architecture at the university in Stuttgart, and upon returning to his studies sometime after the war, he had been selected from a student body of several thousand for a scholarship to the Georgia Institute of Technology as an exchange student. While traveling in Europe years later, I visited Stuttgart and renewed my acquaintance with him. It seems that he had always been interested in the progressive movement in architecture that had been gaining acceptance in pre-Hitler Germany. After the Nazis came to power, this movement lost favor, and with the outbreak of war and the isolation of Germany, the modern movement died. It was not until well after

the war that a copy of the American magazine, *Architectural Forum*, found its way to the school in Stuttgart. He told me that everyone was astounded to see what had been going on in the United States. While Hitler had seen to it that the revolution in architecture was nipped in the bud in the country of its origin, the Germans realized, for the first time, that the Americans had taken over the revolution, which, after a slow start, was advancing unchecked at a rapid pace.

A rchitecture has always been regarded as an art. In the Renaissance there was no clear distinction between branches of the arts. For example, such artists as Michelangelo and Raphael were called upon to practice all three of the major fine arts. To quote from Rassmussen, "The architect works with form and mass just as the sculptor does, and like the painter he works with color. But alone of the three his is a functional art. It solves practical problems —utility plays a decisive role in judging it."

The above quotation emphasizes the two essential elements in architecture: the esthetic or art content and the functional or practical element. In the early phase of the revolution it was function that was the dominant factor, and our society, as it exists today, tends to stress the practical rather than the esthetic. But it should be noted that even the Bauhaus, with all its severity in breaking with precedent, recognized the importance of what the artist had to contribute. In fact, some of the outstanding artists of our time, men like Paul Klee, were members of the Bauhaus faculty at the school in Dessau, Germany.

In our initial reliance upon Europe, there is no doubt that it was the Bauhaus that supplied the major influence in the revolt against eclecticism and that function was given maximum consideration, becoming the guiding motive affecting design. Aside from the usual elimination of ornament, what can be said about the change? Was there a fundamental difference between the new architecture and what preceded it?

The answer is yes. That a fundamental change has occurred is obvious. Let us begin by looking for the reasons.

Practical considerations of functional planning were bound to play a predominant role in design. The varied requirements of vastly expanding industry together with a newly developed contributive technology inevitably resulted in more complicated problems to solve. In contrast to the designer's approach toward traditional architecture, the designer's attention now tended to focus upon the interior where the activities of the occupants are of prime importance, and the exterior, being the outward expression of what went on inside, demanded less attention.

To achieve desired results, symmetry often had to be given up in favor of a less rigid, more informal, irregular plan. This was a departure from historic precedent, as symmetry was an accepted principle in the design of important community buildings throughout the ages. The ancient temple as well as the

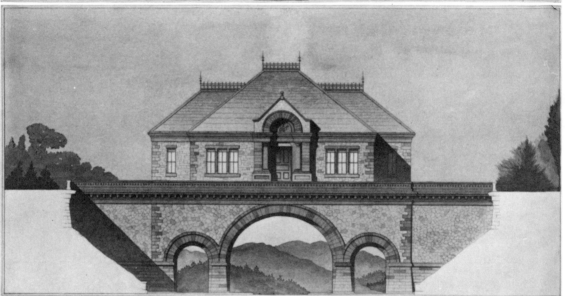

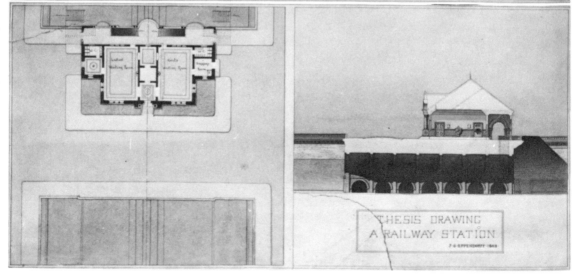

THESIS DRAWING
A RAILWAY STATION

medieval cathedral are noteworthy examples, and it can be argued that the concept of symmetry is still valid where conditions are favorable and the type of project justifies it.

Since we were dealing in the case of the Duxbury Library with the extension of a formal, classical original, it was only natural and logical to extend the main central axis all the way through the addition to the rear wall, thereby making possible a well-balanced composition in which symmetry, except for one minor internal offset, was maintained throughout.

A turning away from symmetry as a guiding principle was one of the major changes brought about by the revolution. Although there may be obstacles to its rational use under certain physical conditions, there may have been other reasons for the rejection of symmetry: perhaps a dislike for formality or whatever might appear to be pretentious or just an innate dislike for anything traditional on the part of the crusaders seeking a new architecture.

The original Duxbury Library building made use of detail in moldings and in ornament, whereas the recently built addition is devoid of it. But here again one cannot assume that the existence or nonexistence of ornament is necessarily significant in identifying contemporary design. The buildings of Louis Sullivan, the first American to break with the past, were replete with ornament; and Frank Lloyd Wright, who followed, continued to make extensive use of decoration. However, one of the essential differences between their work and that of their contemporaries was that their ornamentation was always original—it was their own rather than some form derived from historical sources.

I f neither unsymmetrical design nor a design without ornament can be relied upon as tests in identifying what is truly modern, is there anything positive in the way of definition that differentiates the new architecture from the old? Today's new architecture not only is a metamorphosis of the architecture of the immediate past, but for the first time in history represents a complete break with the entire past.

More specifically, the character of today's architecture results from using new materials and methods of construction that our predecessors did not have and were not aware of, and in taking advantage of these new tools to solve the complex problems of the present, the designer can hardly avoid creating forms,

It is difficult and misleading to think of modern as a style, but in the earlier eclectic era certain design approaches could be classified stylistically. Richardson Romanesque, for example, can be readily identified in John G. Eppendorff's 1883 thesis design for a railway station. Courtesy MIT Historical Collections.

arrangements, proportions, and surface treatments that would have been impossible in former times. If our ancestors were able to see the world of today, they would no doubt be astonished and perhaps horrified by the sights that often seem strange to many of the older generation because the forms are, or were, so unfamiliar.

That is about as far as I can go in the way of a definition. Because of its inadequacy, a final question needs to be asked: Is modern a style in the sense that Gothic or Baroque are styles or in the style exemplified by Trinity Church in Boston's Copley Square—Richardson Romanesque?

Henry-Russell Hitchcock spoke of modern as a style. He called it the international style, but his book was published in the 1930s when the newly emerging architecture was in its infancy and when there was a good deal of talk and writing, but not much evidence to go on.[3] Actual examples, limited in number and owing their distinctiveness to an unprecedented quality of extreme simplicity and restraint, could be found in Germany and Holland and a few in neighboring central European countries. It was not too difficult to see common characteristics in these early departures from tradition. Now that modern design has gained general acceptance throughout Europe and America in all types and categories of buildings, a common denominator is less easy to detect.

It might be well, therefore, to avoid thinking of today's creations as a style, but rather as a growing family of styles in much the same way that classical can be thought of as a family of styles, with some traits held in common but with a recognition that each member of the family is an individual with his or her own features and personality.

Thinking of contemporary architecture in this way is good preparation for the continuing study of what is happening in the evolving, ever-changing scene about us.

Photograph on page 96: At its best, modern architecture is also art. Richard Neutra, whose Grace L. Miller house is shown here, was an artist of domestic architecture. Photograph by Julius Shulman.

8. Modern Perceived as Art

In the previous chapter the attempt to explain modern architecture, brought about by the victory of the revolutionaries, proved to be elusive. The only definite conclusion reached, aside from generalities, was that it seemed advisable not to think of modern as a single style.

If it is conceded that modern is not a style, in the sense that the word "style" has been used, it follows that it is an architecture difficult to define. As it evolved, it became more diverse, eventually making a meaningful definition difficult, if not impossible.

What is manifest and significant, as one views the changing panorama that confronts us, is the realization that the concepts and motivations responsible for what we see are unprecedented. There is, it seems, no longer any infallible guide to rely upon. Complete freedom of expression is granted the designer, and what that freedom entails is restricted only by a single rule: do not look backward, only forward. That, at least, appears to be the conviction held by the early revolutionaries.

Is there, then, anything left in the way of precepts to help the teacher to teach and the designer to design? Are any of the basic principles heretofore accepted as true when applied to the visual arts applicable to the architecture of today? Is it, perhaps, barely possible that architecture is so altered — has been changed in essentials so drastically — that it can no longer be thought of as one of the fine arts?

B efore trying to answer the last question, let us quote Peter Blake from *The Master Builders:* "At no time in the recorded history of architecture has the manner in which men built undergone changes as radical as those which have occurred during the past century." This book is about three men:

1. Charles Edward Jeanneret, a French-Swiss, better known as Le Corbusier or just Corbu

2. Ludwig Mies van der Rohe, a German, later an American citizen

3. Frank Lloyd Wright, an American of Welsh ancestry

"There are others," Peter Blake goes on to say, "who may have contributed more in certain areas, as, for example, Walter Gropius in education, but the three chosen will ultimately appear more important than their contemporaries because they are greater as artists."[1]

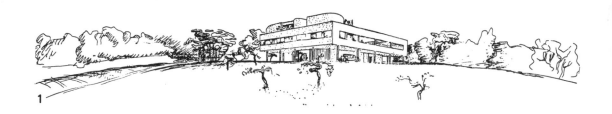

1. Sketch of the house and site
2. Ground-floor plan
3. First-floor plan
4. Roof plan
5. Cross-section through ramp

Le Corbusier, one of the acknowledged masters of the modern movement, blends art and architecture indistinguishably in design conception, presentation techniques, and detailed execution. Drawings of the Villa Savoye in Poissy, France. Courtesy Artemis Verlags AG.

4

3

5

To supplement this statement it should be pointed out that the architect, because of his special interest and training, is the only one within the building industry committed to the outlook and objectives of the artist. Of the many capabilities demanded of the architect in his professional practice, it is his role as artist that is of greatest importance. You may disagree with Blake about his selection of one or more of the three, but it is my belief that if an opinion poll of practicing architects were taken, few would take exception to the basis upon which the selection was made.

Many people may find it difficult to accept the idea that the strange and seemingly inexplicable forms that characterize much of our architecture are the work of the greatest artist-architects. This is something everyone has the right to question, just as one can question the assertion by certain historians and art critics that Matisse and Picasso were two of the greatest painters of their time. That will have to be left for future generations to decide—if such questions can ever be decided conclusively.

What can be said, however, with some certainty is that it would be difficult, if not impossible, to find general agreement on any other selection of three men whose work, as a trio, better illustrates the new architecture — its originality and its diversity. And the same can be said about the magnitude of their influence. These were no converts — it was their religion from the beginning. They lived a long and active life, productive to the end. They took a leading part in the inception of the revolution and in molding the new order; they lived through its time of trial and eventual triumph; and all three finally received the recognition they deserved. They all died within several years of one another—Frank Lloyd Wright in 1959, Le Corbusier in 1965, and Mies van der Rohe in 1969.

If proof is needed that each of these three men has the outstanding qualifications claimed by Blake, it should be sufficient to point out that Le Corbusier was a painter as well as an architect and that his work is recognized as the highest quality among abstract painters, although he was too engrossed in his many architectural projects to have much time to devote to painting. Mies may seem less qualified to be thought of as an eminent artist, but one should take note of the nude figure he selected and placed in exactly the right spot in the courtyard of the Barcelona Pavilion, which is in striking contrast to the severe, rectangular planes of the building. That finishing touch thereby helped make this a masterly composition. As for Frank Lloyd Wright, his status as an artist needs no defense. Anyone who has seen his superlative drawings and witnessed the relationship between his buildings and grounds is at once made aware of his imaginative command of the visual. To achieve harmony and unity with nature takes the eye and the hand of an artist. The account of the life and works of Le Corbusier, van der Rohe, and Wright should convince even the most skeptical that all three were great artists. This then gives us the answer to the question posed previously: architecture as practiced by well-recognized and respected members of the profession in this modern era is still very much an art.

Since these three names have been linked together, you might feel that they should be thought of as a team, a kind of Russian troika, let us say, all trotting along at a uniform pace guided by a driver called art and all headed for the same destination. Nothing could be further from the truth. What has been written about all three offers us insight into their thinking and motivations. Wright and Le Corbusier were prolific writers, both were magnetic and forceful speakers, and a great deal has been written about them. It is interesting to note that they differed on almost everything.

Let me mention here only one of these differences as a case in point: their ideas about the city. While both deplored the 20th-century city, Wright advocated that it be done away with and replaced by innumerable relatively small planned communities in rural settings that he explained and illustrated by his typical imaginary town of Broadacre. Le Corbusier saw no need to abandon the city, even it if were possible to do so. He thought of the city as a great and challenging institution. What he regarded as essential was rather a complete overhaul, an alteration, or more than that, a metamorphosis in which very tall buildings would prevail, but each group of buildings would be related to adjacent open land preserved as parks and playgrounds. His penetrating reaction to the skyscraper during his first visit to the United States is described in his book, *When the Cathedrals Were White*, a title that might give a false idea of the subject. It is an account of his experience—full of surprises—dramatically revealing the author's admiration for the constructive achievements in the American metropolis, but equally condemning the misuse of the skyscraper in relation to its setting.[2]

Mies van der Rohe was a very different type. My only contact with him was at a reception of The Fellows at the Harvard Club in Boston during an AIA convention. Seeing Mies unattended, I introduced myself. He was one of the men whom we hoped to induce to come to Atlanta as a visiting celebrity, and here was my chance to invite him in person. From his friendly smile and brief reply of acceptance, I thought it would be only a question of making final arrangements. But in the ensuing correspondence, fixing a date seemed to run into insurmountable obstacles, and the visit never took place.

My own experience, therefore, seemed to confirm his reputation as a man who shied away from public appearances and speechmaking. Mies was not a man of words. While he lacked the effervescent personality of a Wright or a Corbu, his thorough knowledge of materials and his imaginative comprehension of their potentialities have given him an unchallenged position of leadership in creating a pattern in urban architecture. Its effect can be seen in every major city in America—an effect that is meritorious in his own work, but not always so successful in the work of his imitators. It is the undistinguished standardization and repetition in the work of others that has led to a deadening monotony in much recent construction. In his own work van der Rohe was the personification of the Bauhaus, dedicated to bringing together art and industry in the common cause of reform and expansion made possible by the effective use of science and technology.

Mies van der Rohe, another master of the modern movement, was dedicated to bringing together art and industry through the effective use of science and technology. Block plan of the Seagram Building in New York. Courtesy Artemis Verlags AG.

The work of Le Corbusier, van der Rohe, and Wright well represents the extraordinary development of the 20th century. It would be a mistake, however, to conclude that these three creative giants were the exclusive contributors to imaginative and far-reaching innovation. As time passed, there were many others who took part in leading the way towards acceptance of the new architecture.

One of the most interesting of these innovators, mentioned in Chapter 1, was Eliel Saarinen. In visiting his school, Cranbrook Academy outside Detroit, I was impressed by his unorthodox methods of teaching and by his insistence that no matter what the subject of their design problem might be, his students should consider its relationship with its surroundings—a process that often led to community or even city planning.

The buildings at Cranbrook were designed by Saarinen. One of the many spots of interest in the extensive gardens alongside the dormitories and studios of the art complex is one of the fascinating fountains by Carl Milles featuring a floating group of figures emerging from the spray. Carl Milles is a noted Swedish sculptor who had been induced to come to this country to teach at Cranbrook where sculpture, painting, and architecture were joined in a single educational program. I mention it here to illustrate how Europeans coming to this country have been prominent in fostering the arts.

While Saarinen was never an imitative traditionalist, neither was he ·a machine-age functionalist. It is tempting to surmise that a man like Saarinen, whose youth and early manhood were spent in Finland, a country separated from the cultural centers of Europe, could more easily develop a creative style of his own. That he had not been subjected directly to the teachings of either the Beaux Arts or the Bauhaus may have been to this advantage when he entered the international Chicago Tribune Tower competition, which established his fame and brought him to the United States to become an American citizen.

Another architect, originally a European, is worthy of mention because of his influence in showing the way towards a new architecture—Richard Neutra. As a native of Austria and a resident of Switzerland, Neutra had already made a name for himself in Europe as one of the avant garde. In the early 1920s his travels in the United States led him eventually to the West Coast, where he established his home base in southern California. Illustrations of his work, including unique examples of modern houses, began appearing in the architectural magazines, insuring his reputation as a successful innovator.

My acquaintance with Neutra came about in the following manner: One of the two-week seminars for teachers of architecture in which I became involved after retirement was scheduled for June–July 1958 in Aspen, Colorado. Neutra was asked to take part. When he became aware that we did not have the funds to pay his usual fee, he offered to come for nothing, calling it a vacation for himself and his wife.

A person who creates is not apt to be the best one to explain what he is doing and why he is doing it. In this Neutra proved to be an exception. No one could have entered into the discussions more wholeheartedly in the long evening sessions.

Neutra's ideas are discussed in his book *Survival through Design*, which, regrettably to me, is not illustrated. It does present his life-long search for an original architecture that takes into account the need for satisfying man's psychological as well as biological needs.[3]

I f we go over the names of those who led the way towards a new architecture in America, beginning with Gropius because of his preeminence as an educator and spokesman, taking the three chosen as master builders by Peter Blake —Le Corbusier, Mies van der Rohe, and Frank Lloyd Wright—and adding the names of Saarinen and Neutra, it may seem surprising that of these six, only one, Frank Lloyd Wright, was a native of the United States. Of course, there is nothing new or unusual about our dependence upon our mother country, England, and upon Europe as a whole. Cutting our ties with England politically in the Revolutionary War of 1776 seems to have had little effect upon the continuing influences from abroad in the direction American art and architecture have taken until after World War II.

There are two other architects who can be added to the list of Europeans exerting a continuing leadership: Marcel Breuer, a native of Hungary, who was brought here by Gropius as a teacher and partner in practice, and Alvar Aalto, who came here to erect his design representing Finland in the 1939–1940 New York World's Fair. Both men were recognized throughout the Western world as great innovators, and although Aalto is not so well known in America, Giedion gives him more extensive coverage in his book than that granted to Corbu, Mies, or Wright.[4] His unique contribution in the layout of buildings and in his furniture was the extensive use of the curve—a form that was often at variance with common practice.

One cannot help speculating that Eliel's son, Eero Saarinen, in his remarkable career as an architect, was influenced by his fellowcountryman, Aalto. In the buildings at MIT and Yale and in his airports, Eero Saarinen has made successful and appropriate use of the curve. In the Gateway to the West at St. Louis, the very tall, slender arch is in the form of a parabola, a curve that is self-contained, exerting no inward or outward thrust.

How do we explain that throughout our history we have been inclined to look to Europe and to Europeans for guidance? It is often said that in opening up a new land Americans have been too busy to allow time for cultivation of the arts. Whatever validity there is in this explanation, it does not fully cover the circumstances brought about by war and the arrival on our shores of the many prominent artists and architects escaping from Nazism and Fascism. Regardless of the reasons, it is quite apparent that the Europeans provided the major stimulus for change in the early and developing stages of the revolution in the United States.

It should not be forgotten, however, that there were exceptions to the rule — notably Frank Lloyd Wright. From the very beginning of his career he

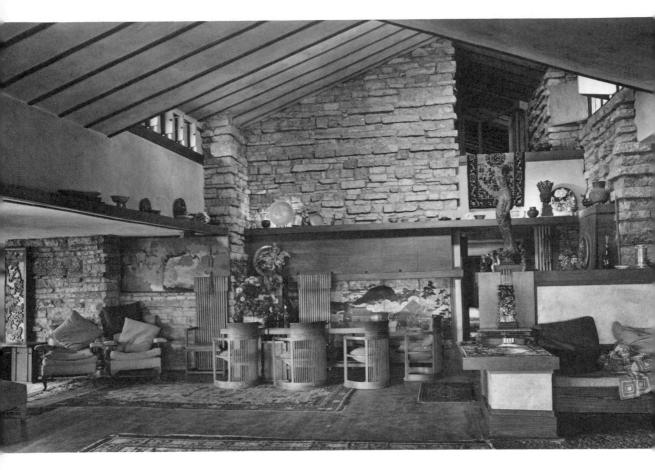

Frank Lloyd Wright's highly individualistic genius—unlike the other masters of the modern movement whose inspiration and frame of reference were essentially European—was firmly rooted in American soil. Interior of living room at Taliesin in Spring Green, Wisconsin, shows Wright's talent for creating innovative living spaces. Photograph by Pedro E. Guerrero.

became committed to the search for and the creation of a new American architecture, free from outside influences. Although he had a following in the Chicago area, he was for a long time ignored or even ridiculed in his own country. Ironically, it was in Europe where he first received widespread recognition, largely because his work was published by a German firm, Ernest Wasmuth. Wright owed nothing to the Bauhaus. If anything it was the architects of central Europe who learned from him.

Because the emphasis in this chapter is on architecture as an art, let us look at the related art of painting, where a similar breaking away and starting on a new course had taken place.

Several years before my retirement and our departure from Atlanta, an incident occurred that has a bearing on this topic. While spending a few weeks' summer vacation in Duxbury, my wife and I were invited to nearby Plymouth to meet Henry-Russell Hitchcock. In the course of the conversation he told us of a remarkable collection of paintings that he had helped to select. This collection by prominent leaders in the modern movement was located in the small Connecticut town of Marion not far from New Haven, where Mr. Hitchcock was acting in a supervisory capacity on contemporary art and architecture at Yale University. Since this collection could be borrowed for exhibition, we decided to look it over on our way back to Atlanta.

All this led to an exhibition in Atlanta when the Textile Building was completed. It was hung in the entrance space, with its all-glass wall—the part of the building that had been designed for just such a purpose. Thus the first classroom building representing modern architecture on the Georgia Tech campus was, so far as I am aware, the setting for the first exhibition of modern painting in Atlanta.

I cannot say that the majority of people in Atlanta were favorably impressed by either the building or the exhibition. At the time that would have been too much to expect. But there were many who were glad to see outstanding examples of cubist and other types of abstract painting, most of it the work of European leaders in the modern movement. Those genuinely interested in art as it has evolved were ready and eager to greet such a show enthusiastically.

The younger members of the School of Architecture faculty planned and carried out all arrangements for this exhibition.[5] It was introduced to the public by an opening, which included refreshments and appropriate music — an enjoyable gathering always to be remembered.

Through the duration of the exhibition the show continued to draw crowds who were curious about what was going on in the world of art. Incidentally, one of the paintings was by the artist-architect Le Corbusier, one of the many internationally familiar names represented.

I did not realize at the time and have learned only recently that this

showing had an effect upon the teachers and students giving and taking art courses at the University at Athens, Georgia. They drove the 70 miles to Atlanta to see original paintings by famous artists whose work they had only known from photographs and reproductions.

Having noted the role played by some of the principal actors in the drama that was the revolution in architecture and the arts, having observed their influence, and having seen how the aims that they stood and fought for were being realized, let us observe a turn—not a turnabout, but a slight change in direction—in the practice of architecture.

Photograph on page 108: Symmetry, essential to the Beaux Arts approach to design but not a basic design principle of the modern movement, has reappeared in recent years. The Hilles Library at Radcliffe College, designed by Harrison & Abramovitz and completed in 1966, is symmetrical in plan as well as elevation. Photograph by Alexandre Georges.

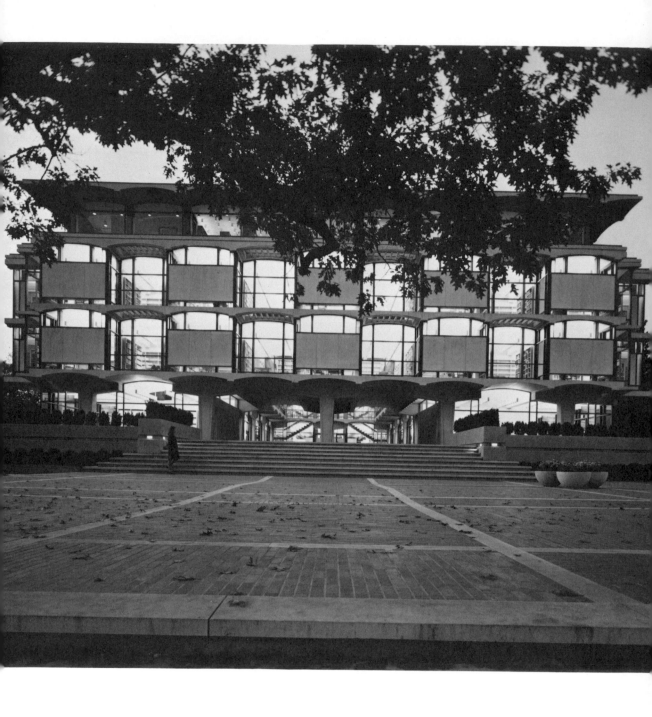

9. The Aftermath

Even before World War II, a new approach to design had been inaugurated in architecture schools, where an increasing number of teachers and students were taking part in the revolt against eclecticism, and after the war, more and more architects in their practice were beginning to accept the inevitability of the new order. By midcentury, or a few years thereafter, the fight was over, the battle won. It is possible, therefore, to name the period that followed "the aftermath of revolution." My own experience leads me to believe that it was characterized by a withdrawal from extreme points of view, accompanied by an easing of tension within the architectural profession. Perhaps this is a natural sequence after a conflict has been resolved.

Before examining the shift in viewpoint during the aftermath, we should review the source of inspiration that dominated the preceding era. To a large extent it came from Europe. However, there were signs that America was beginning to assert its independence by charting its own course in art and architecture.

This is not to say that influences from abroad suddenly ceased. In addition to those already mentioned, I am reminded of Pietro Belluschi, who was born and educated in Italy and who, after a meteoric career in the United States, became Dean of the School of Architecture and Planning at the Massachusetts Institute of Technology. I must also mention Jose Luis Sert, of Spanish and Parisian background, who was made Dean of the Harvard Graduate School of Design. Both are now retired.

As the ranks of the original pioneers from Europe were depleted by death or retirement, it is the oncoming generation of American-born architects, educated in U.S. schools of architecture, who have been taking their place.

A good example of an American firm that has risen to prominence is Skidmore, Owings, & Merrill. I have heard that the three principals happened to meet and planned their partnership while waiting to be sent back to the United States at the end of World War II. Their practice, starting with a New York office, went through an extraordinary growth, with additional offices opened in Chicago and on the West Coast. One world-famous example of their work — the Lever House on Park Avenue, New York — exhibits an advanced approach to the problem of urban architecture by making use of a forecourt. The result is that the high-rise portion of the building is pushed back from the street, thus creating a sense of external space in place of the usual

If the inspiration of the pioneers of the modern movement came from Europe, succeeding generations have sent a counterinfluence to Europe from America; the skyscraper is after all an American invention. Lever House (right), designed by Skidmore, Owings, & Merrill in 1952, is across Park Avenue from the Seagram Building (above), designed by Mies van der Rohe in association with Philip Johnson of New York in 1958. Note the corner of the Racquet and Tennis Club above (also shown on page 17). Photographs by Julius Shulman.

unrelieved overcrowding. I mention that particular work of the particular firm only as an example of what typifies an imaginative response to this kind of contemporary problem encountered by countless other American architects. It is in the city where our troubles are largely concentrated, and it is these problems that were now being attacked by American architects and planners.

The skyscraper, after all, was an American invention, and it presents problems of enormous difficulties because of resulting conditions such as traffic congestion. But in spite of the unfortunate effects largely due to the uncontrolled proliferation of the skyscraper, other countries have felt impelled to adopt the mechanical and structural marvels of Yankee ingenuity — the automobile, the expressway, and the high-rise buildings of the American city. The troubles accompanying the import of these American inventions may account for the increasing number of visitors from foreign countries. Asians as well as Europeans are coming to the United States to find out by personal observation what these tall city buildings are like and how they function—the offices, apartments, hospitals, schools and colleges, as well as the many large-scale developments in town and country. That not all these visitors are pleasure-seeking tourists is borne out by the fact that some students from foreign lands are registering in our schools of architecture.

What a reversal from times past when travel and study in Europe was considered a most desirable, one might almost say a necessary, extension of the American architect's education! Certainly there has been no decrease in travel abroad by students and practicing architects, but the incentive is not quite the same as formerly when a detailed knowledge of historic styles was considered part of the architect's equipment. Now travel to other countries is looked upon more as an inspirational experience and perhaps as an attempt to capture a better understanding of basic principles inherent in all good design of whatever locality or of whatever period of time.

It was not so long ago that American architects and environmentalists interested in overall planning would go to England to study the New Towns cropping up in various parts of the country and visit community developments on the war-torn continent. Now at least a beginning is being inaugurated in the United States in such projects as Reston, outside Washington, D.C., and in Columbia, Maryland, between Washington and Baltimore. The still more difficult task of revamping the existing core of the city is underway in Philadelphia, Boston, San Francisco, and many other cities. To what extent it will be successful remains to be seen.

The point is that America is showing signs of taking responsibility to overcome some of the seemingly insurmountable obstacles brought about by the remarkable assets but questionable benefits of the machine age. The problems confronting us, however, are not limited to the city. As our society becomes more complex, the American architect is being called upon to meet the challenge of the expanding economy.

It is important, then, to realize that during this aftermath people throughout the world began to focus on the one country that had advanced most dramatically in technical achievement and was now looked to for leadership in

meeting the problems and pointing the way towards the realization of a more habitable world.

There is a different matter that involves a change in attitude towards tradition—what could be called a retreat from the hard line of the revolutionaries—and that has to do with symmetry. Symmetry as a basic principle was not characteristic of modern design, and yet it has reappeared in two recent examples with which I am familiar: the Radcliffe Library in Cambridge and the Countway Library in Boston. The first was adjacent and related to a group of formal classical dormitories; the second, similarly, served as an extension of the formal classical Harvard Medical School. If you consider who the architects were, neither of these two projects could be anything but modern: the Radcliffe building was designed by Harrison & Abramovitz of New York and the Countway by Hugh Stubbins. Both buildings are unquestionably symmetrical in plan as well as elevation, with the main entrance and central court on axis and everything in balance. Here we have proof that an overall precept and guide throughout history was not to be permanently rejected and can still play a part in modern architecture whenever justified by circumstance.

It is quite evident that the extreme radicalism of the early days of the movement has been calming down. What was a further enlightenment came to me during a conversation I had with the young architects being considered for the Duxbury Library project. I wanted to test them out on how they felt about our architectural inheritance. I told them of my experience in Atlanta: how students and younger members of the faculty at Georgia Tech no longer had the slightest interest in anything traditional, to put it mildly. I mentioned that one of the new radical teachers had said that the books in the library should be taken out and burned.

The response of the two men who were to be the architects of the library came as somewhat of a surprise. They assured me that everything had changed. As it turned out, they were soon to show that commitment to the modern movement did not necessarily preclude recognition of the values of the past nor prevent relating a modern building to an historic one.

To quote from "A Descriptive Handbook" of the Countway Medical Library: "It is a building which illustrates the view that the day of pure and unrelieved functionalism in libraries, happily, is past; that modern libraries to fulfill their purpose properly must provide beauty as well as books." For an historian and former traditionalist it is a pleasure to see the word "beauty" coming back into use—without apology.

The above quotation is another indication that victory by the revolutionaries in the battle to supplant early 20th-century architecture with something new did not bring about a permanent and unyielding settlement. No matter how complete the victory, art and architecture continue to be

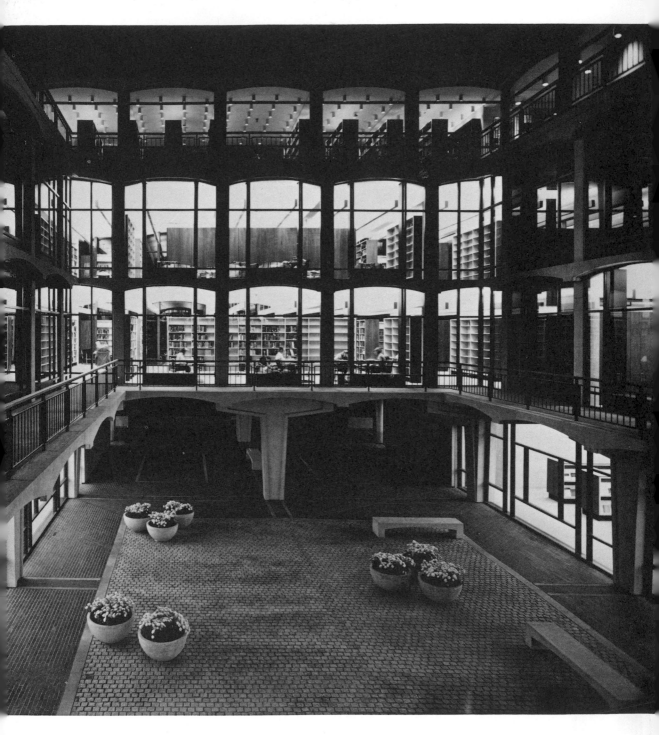

The classical tradition finds a new expression in uncompromisingly modern architecture as shown in the Hilles Library at Radcliffe College and the Francis A. Countway Library of Medicine in Boston. Symmetrical in plan and elevation, both have the main entry and central court on axis. Hilles Library (above) was designed by Harrison & Abramovitz and completed in 1966. Photograph by Alexandre Georges. Countway Library (right) was designed by Hugh Stubbins and Associates from 1961–1964. Photograph by Louis Reens.

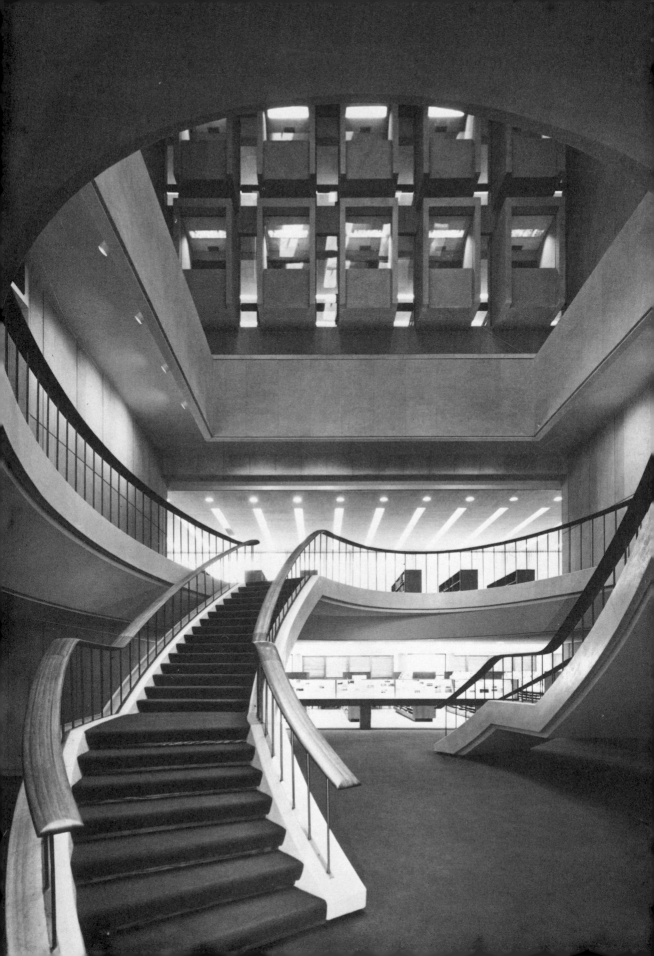

forever changing, and that is as it has always been throughout history.

Further evidence of a modification is found in the writings of Bruno Zevi, a young Italian author and architect who was a resident of the United States during the war when Mussolini ruled Italy. Although he had already graduated from the university in Rome, he took advantage of his temporary stay here to continue his study, and he received a degree in architecture from the Harvard Graduate School of Design. His beautifully illustrated book on modern architecture concentrates on the masterpieces of the past as well as the work of Frank Lloyd Wright and other modern architects.[1]

These brief references to a gradual change of outlook in the years before the construction of the new library in Duxbury may help to explain the character of this little building and also the reactions towards it. The New England town, because of its long, unbroken history, can be expected to be strongly resistant to change of any kind. Not so many years ago, the citizens of Duxbury probably would have shuddered at the thought of such a radical departure from the usual time-honored tradition of our town. Now, however, the fact that people were not only willing to accept but in many instances expressed approval of a modern building in their midst is a matter of some importance. If this new architecture can gain acceptance here, it is proof—if proof is needed—that the justification for modern design in public buildings is no longer challenged and is in fact taken for granted.

The reluctance to change still exists in the continued colonial and federalist character of the New England church and home, where the nature of the problem is much the same as it has always been. But there is no assurance that even these holdouts for tradition can resist the call of the future for very long. There is no reason, however, why restoration and maintenance of tradition in a town like Duxbury should not continue as long as it is desired, and there is every reason for preserving the good examples of a fine inheritance.

There is still the unanswered question: what are the essential differences between modern and traditional? To what extent have basic principles been discarded for new principles, or do the differences lie only or primarily in a change in emphases? Is it that such a concept as variety within unity has gone forever? Are balance and harmony as well as rhythm qualities no longer required or sought after?

Questions of this kind will have to remain unanswered. The best I can do is refer the interested reader to the authors mentioned previously and to an additional work by John Burchard and Albert Bush-Brown. This book, entitled *The Architecture of America*, was written in celebration of the 100th anniversary

of the founding of the AIA in 1857. The prologue under the heading, "The Nature of Architecture," deals with the essential qualities found in the art of architecture. The explanations are extended and helpful for anyone who searches for understanding in the realm of the abstract.[2]

A final observation: contemporary writers and critics seem to agree on what constitutes one essential of modern architecture, and that is the concept of space as a major concern of the architect of the present era. An indication of this preoccupation with space is in the headings used for one-third of Peter Blake's book, *Frank Lloyd Wright and the Mastery of Space*, in the title and contents of Giedion's book, *Time, Space and Architecture*, and in the title and contents of Zevi's book, *Architecture as Space*. Zevi is careful to insist that his conception of architectural space is not limited to enclosed space, fundamental as that is. It also includes the relationship of a building to the spaces that surround it.[3]

Although former critics and some architectural historians may have failed to see architecture in these terms, the creators of most of the masterpieces of the past must surely have been motivated, perhaps unconsciously, by this feeling of sensitivity to space—the quality of space as an overriding motive—in the same way as their counterpart is motivated today. Whatever else may be said, this interpretation of architecture is certainly broad enough to include the past as well as the present and to raise value judgments to a level above the battle.

Notes

Introduction

1 The story of this and other episodes is told in the book written by my adopted aunt, Eliza Orne White, entitled *Edna and Her Brothers*.

Chapter 1

1 Louis Sullivan, *The Autobiography of an Idea*, New York, Dover, 1956. Sullivan's book is actually the story of his life, in which he stresses that he is searching for a basic principle that would be all-inclusive. He sums it up in three words, "Form follows function."

Chapter 2

1 Brown & Harris dorms were designed by Skinner, Bush-Brown, & Stowell and published in *Architectural Forum*, June 1931.

2 Brittain Dining Hall was designed by Harold Bush-Brown and published in *Architectural Forum*, June 1931.

Chapter 3

1 West stands of the grandstand were designed by Bush-Brown & Gailey, with associate architects P. M. Heffernan and R. L. Aeck, and published in *Progressive Architecture*, June 1948, pp. 47–52.

2 The Harrison Hightower Textile Building was designed by Bush-Brown, Gailey, & Heffernan and published in *Architectural Record*, June 1950, p. 12.

3 The architecture building was designed by Bush-Brown, Gailey, & Heffernan and published in *Progressive Architecture*, July 1955, pp. 95–98.

4 Georgia Tech Library was designed by Bush-Brown, Gailey, & Heffernan and published by *Architectural Forum*, March 1955, pp. 126–129; see comments by John Burchard therein.

Chapter 6

1 Bernard B. Rothschild, FAIA, FCSI, is a member and former chairman of the AIA Documents Board and a member of the Atlanta firm of Finch, Alexander, Barns, Rothschild & Paschall. This quote was taken from my correspondence with Rothschild with his permission.

Chapter 7

1 Thomas E. Tallmadge, *The Story of Architecture in America*, New York, W.W. Norton, 1936.

2 Steen Eiler Rassmussen, *Experiencing Architecture*, 2d ed., Cambridge, Mass., MIT Press, 1962. Rassmussen is an eminent Danish architect, teacher, and writer.

3 Henry-Russell Hitchcock and Philip Johnson, *The International Style*, New York, W.W. Norton, 1966.

Chapter 8

1 Peter Blake, *The Master Builders*, New York, Alfred Knopf, Inc., 1960.

2 Le Corbusier, *When the Cathedrals Were White*, New York, McGraw-Hill Book Company, 1947.

3 Richard Neutra, *Survival through Design*, New York, Oxford University Press, 1954.

4 Sigfried Giedion, *Space, Time and Architecture*, Cambridge, Mass., Harvard University Press, 1949.

5 D.J. Edwards was in charge, and Marianna Edwards, his wife, was on refreshments.

Chapter 9

1 Bruno Zevi, *Architecture as Space*, New York, Horizon Press, 1957.

2 John Burchard and Albert Bush-Brown, *The Architecture of America: A Social and Cultural History*, Boston, Little, Brown & Co., 1961.

3 Elizabeth Gordon, editor of *House Beautiful*, says: "Bruno Zevi offers us the key which unlocks architecture throughout the ages. And that key is simply this: the reality of a building is not its walls or its roof, but the space it encloses." This quote was taken from the back cover of Zevi's book, *Architecture as Space*.

Appendix

One cannot speak of the origin of the Duxbury Free Library without mentioning the Wright family, who, it is reported, came to Duxbury about 1870, "the first foreigners," whatever that phrase signifies. The Wrights lived in a mansion on an estate opposite the library site—undoubtedly the wealthiest family in town. One record mentions the name Georgianna B. Wright as the donor of the library. It is interesting to note that it was the woman in the Wright family who sponsored the idea of a new permanent building for the library, endowed it with a strong healthy body, and ensured its future.

After the turn of the century, new libraries were being built in the towns of eastern Massachusetts as elsewhere. No doubt it was due in part to the stimulus given by Andrew Carnegie who provided funds for city libraries all over the country, thus making people aware of the importance of the library as a community institution, a symbol of its worth just as the church had always been. That the Wrights and the Trustees felt this way about it is evident from the fact that, for the first time, the town of Duxbury had a masonry building in its midst.

We do not know who selected the architect to design the Duxbury Library, Mrs. Wright or the Trustees, or what considerations led to employing Joseph Everett Chandler. Nor do we know whether anyone had any definite ideas about what was wanted. But the building that emerged was in line with the background of this particular architect, and it is not unreasonable to suppose that he was given a free hand.

While Chandler certainly had to submit his drawings for the approval of Mrs. Wright and the Trustees, he did not have to go before the annual Duxbury Town Meeting as did the architects of the addition in March 1966. Having lived in the South during most of my professional life, I was now being introduced to the procedures of the New England Township, which, it seems, are unique to that part of the country. Adhering to the principles laid down by the Pilgrims when they came to this land 250 years ago, the people of the community make the important decisions in an open meeting by vote of the majority of those attending.

The drawings of the proposed addition were ready to be shown to the residents assembled in the high school gymnasium, and there were preliminary estimates of costs. We were asking for a vote of approval on what we were doing, but decided against final commitment because we wanted more time for restudy and resubmission to the state for funds to be supplied by the federal government.

In the Article of the Warrant, as it is called, we were asking only for enough money to pay the architects to go ahead with working drawings. The

Study Committee would carry on for another year. This would give ample time for restudy of particulars, and at the next town meeting we would have an accurate estimate of costs. Then, if approved, the town would be in a position to negotiate a contract to build.

This seemed to be a reasonable proposal, but in spite of attempts to keep the community informed of the need for and the value of expanding the library, it became evident that there was opposition. How much opposition we did not know, but we were soon to find out.

The first blow was the refusal of the Finance Committee to give their support. Then came the questions and the voices of dissent. It was the increase in taxes that people were afraid of.

The time-honored quip, "Where's the money coming from?" brought a quick response from Francis E. Park, the man on our committee dealing with finances. "From the same place that all the other appropriations are coming from," referring to the Middle School, the Police Station, the proposed Fire Station, etc.

For a moment that seemed to cause a halt, but not for long. It was getting late, and more and more people were leaving.

The opposition changed tactics. They sensed, no doubt, that most of those who were in favor of expanding the library were willing to wait for a vote, so a resolution to adjourn was put forward and reintroduced with more vehemence as Bartlett B. Bradley, the Duxbury Town Moderator, stalled, wishing to give all a chance to be heard, but obviously bent on permitting a vote before adjourning the meeting.

At last the vote came: those for—a good response; those against—making a powerful impression by the loudness of the no's. We had to wait for a count by the tellers. Finally the announcement came. It was a close call, but we had won and could now go ahead with well-thought-out large-scale plans and specifications for a new library.

A whole year seems like a long time to wait for final approval after the preliminary drawings are accepted. I have found, however, that delay often has its advantages, and this, I think, is especially true in the process of finalizing the design of a building project. As soon as the working drawing stage begins, everything becomes fixed, with less and less chance for second thoughts.

Furthermore, we still had a selling job to do to satisfy the Finance Committee and make sure that next year we would have the backing of the majority of voters.

There was also the matter of financial support from the government and from public-spirited citizens. In this we were fortunate to obtain a grant from the federal government and a gift to be applied to the cost of the children's wing, which was announced in advance of the March 1967 annual Town Meeting.

Whatever may have been the reasons or motives that actuated the voters, the approval given the library project this time was overwhelming.

Soon after the March 1967 meeting a Building Committee was appointed

by the Moderator, with three holdovers from the Study and Advisory Committee: Harold Bush-Brown, chairman; Francis E. Park III, vice chairman and treasurer; Richard C. Crocker, local builder. As we inherited from the former committee a complete set of documents, the so-called working drawings, it might seem that all we would have to do was select a builder, agree on the price, sign a contract, and start work.

But it was not quite that easy. To begin with, competitive bidding is required by law on all public building with advance notice in the press, giving all those qualified the right to come forward with a proposal. It is a complicated and time-consuming process. On the library project the low bidder's estimate of total cost was considerably less than his competitors. Although he was not the contractor we would have chosen, an investigation failed to turn up anything to disqualify him, and following usual practice, he was awarded the contract and work began in midsummer.

There was a competent superintendent in charge of operations for the general contractor, and everything seemed to be going well. But there were disquieting rumors, and in the fall of 1967, the man whom we had engaged as clerk-of-the-works to look out for the interests of the town on the job, Samuel Fuller, a registered engineer, alerted us to the fact that construction was behind schedule. As time went on, complaints kept coming in that payments due subcontractors and material suppliers were being delayed or withheld. By the spring of 1968, as the work continued to slow down, it became evident that strong action was necessary.

The situation that confronted us was one with which I had some familiarity. During the First World War, after joined the Navy, I was sent by the Bureau of Yards and Docks to the submarine base at New London, Connecticut, where I was assigned to oversee inspection on certain buildings under construction. One of the contractors was brought to trial by his subcontractors because he failed to meet his commitments. It was agreed that this must not happen to us here and now. On the advice of Louis B. Tura, the Boston contractor on our committee, we engaged a lawyer, Vincent P. McCarthy of Hale & Dorr in Boston, who eventually brought about a successful settlement in July 1970. In spite of delays caused by strained relations between the general contractor and his subcontractors, work continued, if slowly, and there was never a complete breakdown of operations.

As the project neared completion in 1968, Marjorie Bush-Brown suggested that an art gallery be created in the rotunda area and the west wing. A public-spirited Duxbury resident, Mrs. H. C. Bumpus, Jr., told me of her wish to make a donation to the library, which was sufficient to cover the cost of any plans we might have for restorations and alterations in Wright Hall (the original building). When I asked her how she felt about the proposal for creating an art gallery, she said she would gladly support it. The Trustees, however, were not so sympathetic. They had taken it for granted that the west wing would be for books. To assume that a library should take on the responsibility for serving the arts was a new idea. But to those of us who had been on the Study Committee and had seen what other towns were doing,

there was nothing novel or surprising in this assumption, although there is no doubt we were allotting it more space than the others did. Eventually, however, the Trustees gave their consent.

The project was under the sponsorship of the Library Trustees and the Building Committee and was in honor of the donor, for whom the gallery was to be named. The room was furnished by Mrs. W. C. Beckjord, who donated the funds for the furnishings in memory of her husband.

For the opening of the new addition Mrs. Bush-Brown was fortunate in obtaining some of the best examples of the work of artists in the area, which would be on view and listed by title in the catalog of the first exhibition held in the Helen Bumpus Gallery.

It was arranged and hung by a newcomer to Duxbury, Patrick L. Dudensing, a member of the Dudensing family whose name is well known in New York because of their collection and exhibition of the works of famous artists.

One of the paintings in this exhibition was by a summer resident of Duxbury, Charles Bittinger, the founder and first president of the Duxbury Art Association. It was given to the library and still hangs over the mantle in the Beckjord Room. As the subject of the painting is the interior of the Lee Mansion, a traditional classical house across the Potomac from the Washington Mall, it is seen in a perfect setting.

With the opening exhibition in Wright Hall, the original building and the new addition to the library were now joined together and were ready to operate as a single unit. The members of the Building Committee could feel a sense of satisfaction in seeing the enlarged building in full swing with a tripling of available space. We still had to make sure that everything in the contract was complied with (the architect's job) and that no financial claims would come back on the town (the lawyer's job). It was to take more than two years to fulfill these assurances, and until then, the Building Committee could not withdraw.

In the meantime there were some actions that we could take towards improving the product for which we were responsible.

There is a room above the children's wing that came into existence, not because it had been requested, but because it was necessary to carry out the design of the rear south end in a satisfactory manner. It was decided that it should be a reference room for documents to be used by writers and researchers of the history of Duxbury. Thus it came to be called the Duxbury Room.

As has already been brought out, much of the extra work not originally contemplated was made possible by generous donors. The first and (except for the government grant) the largest bequest came for the children's wing from the Grafton Fund under the will of Harry C. Grafton, Jr. One of the members of our committee, Alvah Boynton, was a trustee of his estate. The money had been left to the town to be spent as the trustees should determine, certainly a most unusual bequest. The donor was a bachelor who was very fond of children, and for that reason it seemed appropriate to leave a large share of the income to the library for the portion of the building that would benefit the children. It assured the inclusion of the children's wing as a separate unit.

This support from a number of sources provided the opportunity to incorporate many improvements. At the time, the advantage of delay was not so evident to members of the committee, but, in looking back, I realize that there is no doubt that the project was to benefit by the long postponement of a final settlement.

The last bit of work to receive the signature of two members of the committee, as required, occurred five years after the signing of the contract—a long, but rewarding process.

Index